Postcard History Series

Golden Gate Park
San Francisco's Urban Oasis
in Vintage Postcards

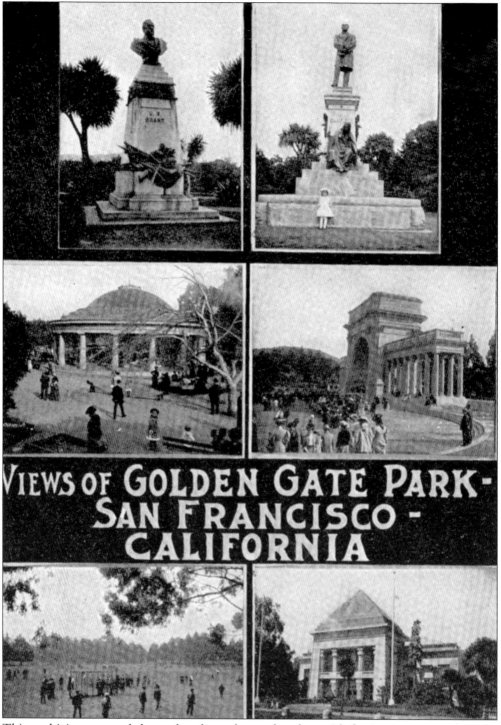

This multiview postcard shows that the park was abundant with fascinating sites such as the Ulysses S. Grant Monument, James A. Garfield Monument, carousel, Spreckels Temple of Music, the Big Rec athletic fields, and the Memorial Museum.

Postcard History Series

Golden Gate Park
San Francisco's Urban Oasis
in Vintage Postcards

Christopher Pollock

ARCADIA
PUBLISHING

Copyright © 2003 by Christopher Pollock
ISBN 978-0-7385-2853-3

Published by Arcadia Publishing
Charleston, South Carolina

Printed in the United States of America

Library of Congress Catalog Card Number: 2003109467

For all general information contact Arcadia Publishing at:
Telephone 843-853-2070
Fax 843-853-0044
E-mail sales@arcadiapublishing.com
For customer service and orders:
Toll-Free 1-888-313-2665

Visit us on the Internet at www.arcadiapublishing.com

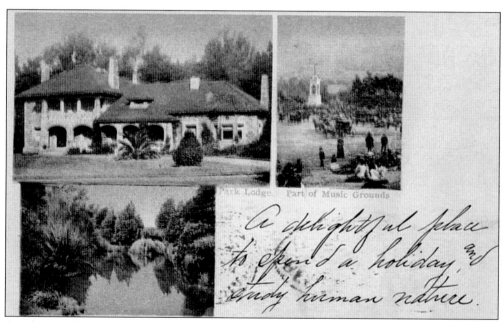

Another multiview postcard, dated 1901, extols the park as "A delightful place to spend a holiday and study human nature." Shown are McLaren Lodge, the first site of the Francis Scott Key Monument (now the tennis courts), and Alvord Lakelet.

Contents

Acknowledgments		6
Introduction		7
1.	Sculptural Tributes	11
2.	Two World-Class Expositions	19
3.	Enlightenment on the Concourse	29
4.	Recreational Pastimes	51
5.	Watery Delights	61
6.	Now Gone	71
7.	Creatures of Many Kinds	79
8.	Fancy Structures	91
9.	Sylvan Vistas	101
10.	Before and After	111
Selected Reading		125
Index for Images		127

ACKNOWLEDGMENTS

Fellow San Francisco Bay Area Postcard Club members John Freeman and Glenn Koch graciously made their expertise available to me for this book. John opened his collection for my use and Glenn was instrumental in letting me know about several special postcards. And my thanks go to the San Francisco Bay Area Postcard Club (*www.postcard.org*) whose interest in this subject is unwavering. The M.H. de Young Memorial Museum, California Academy of Sciences, and photographer Gabriel Moulin previously published some of the images included.

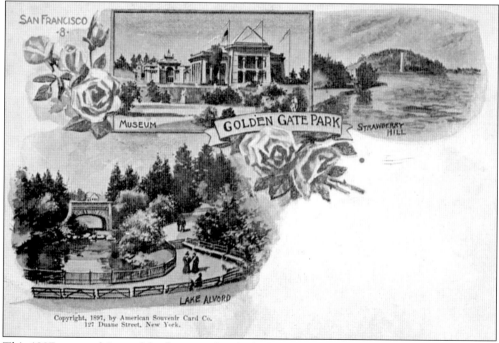

This 1897 postcard (one of the few ever dated) shows the Memorial Museum, Stow Lake with Strawberry Hill in the distance, and Alvord Lake with Alvord Bridge beyond.

Introduction

Golden Gate Park is one of San Francisco's crown jewels, but that was not always considered to be so. Early efforts to establish a park were almost derailed by those without vision of what San Francisco could someday be. The park's origins came from a need by families to commune with fresh air so lacking in the city's center, especially those areas where by-products of industry belched from chimneys.

Discussion (or "agitation" as it was called at that time) for the need of a park began around 1860, but it would be another nine years before the Transcontinental Railroad would connect the East Coast with far-flung California, helping to grow San Francisco into a modern city capable of such a large-scale endeavor. However, the city did have the foresight to take on such a huge infrastructure project. After all, empire-building, based on the concept of Manifest Destiny, was the era's byword. It was this vehicle that helped a fledgling metropolis conclude their need for, and execute one of the West's more ambitious projects.

Construction of the park's design, by surveyor William Hammond Hall, started in 1870 with the Panhandle (the narrow portion closest to downtown), and proceeded westerly to the Pacific Ocean. It would take years from that point to cover the practically barren sand hills with greenery. An article in the *San Francisco Chronicle* on October 24, 1875 was prophetic when it stated that the "design some day shall blossom as the rose." Today, the park is a perennially popular spot, where many of the park's vistas play a role in the ever-popular 49-Mile Scenic Drive as tourists are treated to magnificent views of the city's charms via automobile.

These vintage postcards are a bridge to the past, each telling about a portion of the park's development. This publication augments my first book, *San Francisco's Golden Gate Park: A Thousand and Seventeen Acres of Stories,* by offering many more photographs of the sites I described. While writing that book I became intrigued with a unique form of photograph—postcards illustrating the park. After finishing the book I knew there was a lot more to learn about the park's history than my five-year research project taught me. I saw many postcards during my inquiry, and with that project completed I unconsciously entered the next phase—collecting the cards. I found them at antique shops, flea markets, postcard and ephemera shows, online auctions and e-tail sites. I joined the local postcard club. For me it's the hunt that's the thing—once found it's on to the next quarry.

Photographs of the park are not difficult to find, but they primarily reside in public and private archives. Postcards are an inexpensive way to see into the past, and are amazingly wide-ranging in their subject matter. Curiously, some park monuments, buildings, or sites—some of them important—don't seem to be shown on any postcards that I know of. For example, the Thomas Starr King statue, the Shakespeare Bust, the bowling greens, and the Beethoven monument have not been found in my inquiries. This may be in part because anything installed in the park after what some people call "the golden age of postcards" was not recorded. And yet many of the missing postcards are of items that came before that time.

Many cards were never mailed, but rather kept as a keepsake of a trip just as people do

today. Based on those cards in my collection that were mailed, the heyday of postcards was about 1905 to 1915, a period whose activity culminates with the long-anticipated coming of the 1915 Panama-Pacific International Exposition to San Francisco.

A focused subject postcard collection (deltiology is the collecting of postcards) might seem quite limiting. However, Golden Gate Park covers a broad spectrum of active things to do and passive things to see, much of which was recorded in various postcard forms. View-type cards, the most common type of card, recorded a place. Greeting-type cards have what seem to be a pre-printed message (most commonly showing graphic icons of Christmas) and show a place as well—an odd combination since there is really no relationship. Historical-type cards recorded a special event.

Graphic techniques used in the cards vary greatly, and include some innovative techniques. Many early postcards are the vignette type where the image has an irregular, fuzzy edge and floats within the white cardstock's background. Cardinell-Vincent, for example, created a type printed on matte off-white paper using mostly black lines that resemble an etching. Applied over this are subtle blocks of color, usually in transparent cool tones of blue, green, and sometimes red. An unusual type is the elegant green oval-shaped frame cards with a plaque at the bottom proclaiming the site pictured. These cards were also embossed by their producer, Richard Behrendt, who further layered this onto very glossy paper stock, highlighting their three dimensions. The *Sunday Examiner* newspaper issued a series of cut-them-up-yourself cards, with four cards per sheet, showing the 1906 earthquake's aftermath and fire victims in the park.

Postcards as we know them in the United States came about on May 1, 1893 at Chicago's Columbian Exposition, and this inexpensive form of fair promotion heralded an activity that continues to this day. Those cards, issued during what is known as the "pioneer era," were issued by both government and private concerns. But the genesis of this fascinating type of publication (part of what is broadly called ephemera, the collection and study of printed paper) goes back to greeting cards—some which can be traced to Hungary in 1869. Dealers and collectors alike appreciate the small and lightweight format. Deltiology is a relatively inexpensive pursuit unless you acquire a taste for rare cards that can command hundreds, maybe even thousands of dollars.

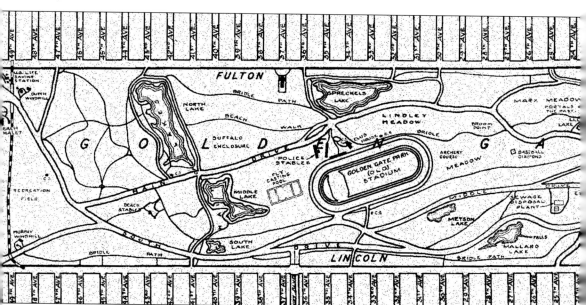

Map of Golden Gate Park *c.* 1928.

Early postcards demonstrate high-quality printing since many came from Germany, which was then the high-tech center of printing. The first cards in general circulation had an undivided back where only the address and postage stamp were allowed on the back, one of the earmarks of this era. The next step was the private mailing card that Congress authorized on May 19, 1898 costing a penny's postage to mail. Real photo postcards, as their name implies, are actual black-and-white photographs that appeared in 1900. Novelty colorations of real photo postcards were sepia-toned, while others, known as cyanotype, were blue. These were either one-of-a-kind or mass produced. They sometimes display a hand-written caption that is part of the negative.

Professionals and amateurs alike created real photo post cards using a specially marked roll of film primarily sold by the Eastman Kodak Company. These cards are not to be confused with black-and-white printed images whose earmark are concentrations of tiny dots that create an image known as a halftone. On December 24, 1901 the modern term "post card" came into use when permission was granted by the federal government to print those words in lieu of a longer authorization inscription.

The divided back era of postcards was launched on March 1, 1907 when the post office allowed both the address and a brief message to be on the card's back. As World War I brewed with Germany, the United States supplied its own postcards starting in the late teens. The white border era (versus most previous cards where the image usually bled off the edge) indicates an American product of this time, albeit an inferior one. The linen era refers to those cards issued after 1930 until 1945. This novelty paper stock (with a high rag content) was textured to resemble fabric, a new gimmick of the time. These were produced exclusively in the United States with a new type of printing process, and the high-intensity coloration glows like Technicolor film while the image seems unfocused.

The first park-specific postcards were introduced when many exhibits for the California Midwinter International Exposition of 1894 were recycled from the Columbian Exposition and with them the concept of postcards. The Midwinter Exposition, held in Golden Gate Park, introduced some postcards which should more accurately be called trade cards, since most had a printed advertisement on the back.

There are many resources that have period photographic evidence of the park's past, but they are mostly in black-and-white. Old postcards that are rendered in color bring another aesthetic

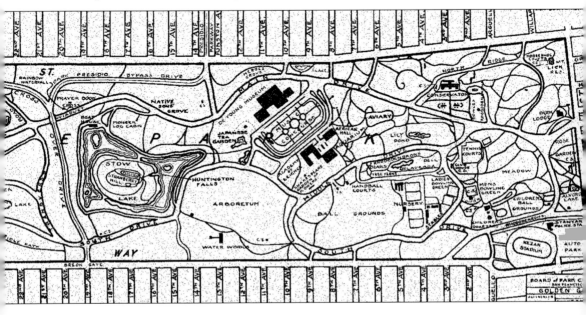

dimension to the table. The colors rendered, however, cannot be considered reliable since a manufacturer's interpretation of a surface color involved a judgment by the individual printer, much like Ted Turner's colorized movies. Despite that possibility, no one might have known that John Roebling's metal suspension bridge that once spanned Middle Drive was painted primarily green. And the 1921 version of the de Young Museum's startling salmon-and-crème colored encrusted decor was certainly not evident. Brightly punctuated floral bedding displays in front of the Conservatory of Flowers were simply not as interesting in sepia-tone. The red roof of the former boat house on Stow Lake was uncertain, and a similar red again appears in the colored concrete of Sweeny's Panorama that once perched atop Strawberry Hill.

Vintage postcards reveal some surprising changes in park structures. Many people are surprised to see Rodin's statue of *The Thinker* placed across Main Drive (now JFK Drive) from the Conservatory of Flowers in several postcards. And near the conservatory was the first site of the Francis Scott Key monument that was later moved to the California Academy of Sciences courtyard and yet again to its current spot. The long-gone aviary, one of two progressively larger structures sited on what is now known as the John McLaren Rhododendron Dell, was pictured in a postcard. The much-loved animal rides in the Children's Playground and the enormous bears in the aptly named bear pit bring about nostalgic memories of the past. As time moves on, many more of the park's resident structures will fall to the cries of "out-of-date" or "not worth fixing," just as it did with these. Thankfully, the popularity of postcards has unwittingly enshrined these elements.

Much like today's TV programs about human foibles, there are the occasional flubbed postcards. The rustic stone bridge at Stow Lake was, in one postcard, stated to have collapsed in the 1906 earthquake—I don't believe this is true. Let me nit-pick for a moment: the spelling of Stow, misspelled with an *e* at the end, occurs on several cards. Another misspelling happens on a card of Roald Amundsen's dry-docked sloop *Gjøa* (misspelled as Cjoa) on Ocean Beach. My favorite title blooper is where the tennis courts are captioned as "Golf Course!" I have also seen a few cards that don't seem to be the park at all. If I could prove this, indeed these might be worth something, like miss-struck coins or misprinted stamps, I suppose.

A note about some of the building or place names used in this book is in order. What is known today simply as the de Young Museum has been known by several different names over its lifetime, starting as an exhibit space called the Fine Arts Building at the California Midwinter International Exposition. This was before the space was officially a museum. The following year "Memorial Museum" was adopted when Michael de Young made the building a museum whose genesis was his collections ("Memorial" in this case referred to the Midwinter Fair). Although the Mulgardt-designed building, started in 1917, was also called Memorial Museum, its name was officially changed to the M.H. de Young Memorial Museum in 1924 a year before the benefactor's death. (The current use of "de Young Museum" came about in 1971.) Several other inconsistencies appear as well, such as the names of the Sharon building and its adjacent playgrounds.

And a final note about the words—read the sender's notes when you find a vintage postcard. The short notes were, and still are, a connection to home or friends, and however vague or dull, these messages tell snippets of people's lives at that time. Not surprisingly, many of the messages talk about the allure of San Francisco and its beautiful Golden Gate Park.

One

Sculptural Tributes

As an outdoor museum the park abounds in three-dimensional sculptural pieces ranging from the demure to the gigantic, and covers an eclectic range of subjects. One by one, monuments were placed in the sylvan oasis, with most pieces being clustered around the Music Concourse located at the more-visited eastern end of the park's acreage, but some do exist in the more rustic western end as well. "Stookie" is the well-publicized, derogatory term Park Superintendent John McLaren coined referring to all those large decorative objects foisted upon the park during his 53-year reign. McLaren had his own subtle weapon when these alien objects invaded his realm–plant around them: he simply let the greenery envelop the offender. With the death of "Uncle John," many of the works were uncovered after years of being shrouded by foliage. Ironically, one statue is of the feisty superintendent McLaren himself, placed posthumously in the dell which takes his name. These kinds of tributes are a remnant of the Victorian Age, and are out of fashion today. Park authorities these days ask that funds donated to the park should maintain what exists, not add to it.

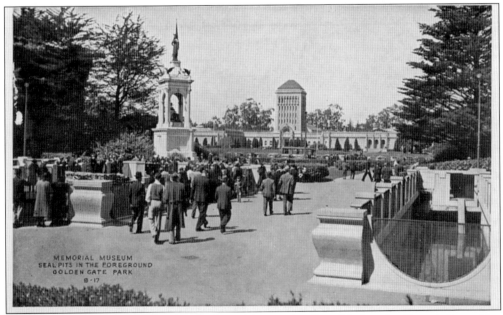

With development of the second bandstand into a site for athletics, the Francis Scott Key Monument was moved to the entrance of what would become the California Academy of Sciences.

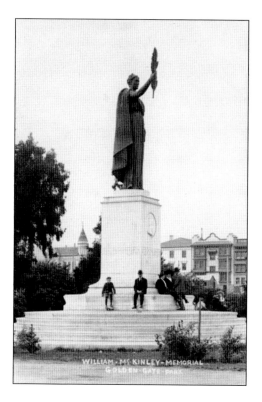

The mammoth William McKinley Monument, memorializing the assassinated 25th U.S. president sits at the eastern end of the Panhandle and acts as an introduction to the park's marvels. This work's groundbreaking was performed by McKinley's successor Theodore Roosevelt on May 13, 1903.

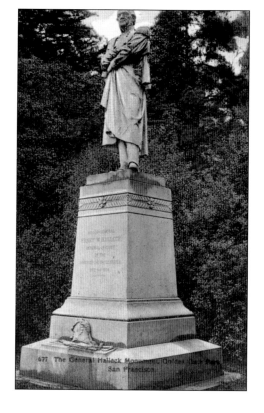

Carl Conrads's granite depiction of Maj. Gen. Henry Wager Halleck was acquired for the park in 1886. Halleck was the general-in-chief of armies from 1862 to 1864 and was a member of the committee that created the California Constitution.

San Francisco land magnate James Lick provided funds for the Francis Scott Key Monument because he was in Baltimore during the shelling of Fort McHenry—the event that inspired Key to write what became the U.S. national anthem. The memorial was constructed of travertine, marble and bronze. On top stands the Goddess of Liberty surrounded by eagles while Key sits shielded from the elements under a canopy.

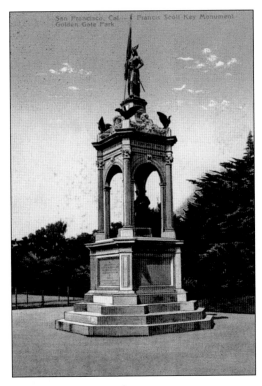

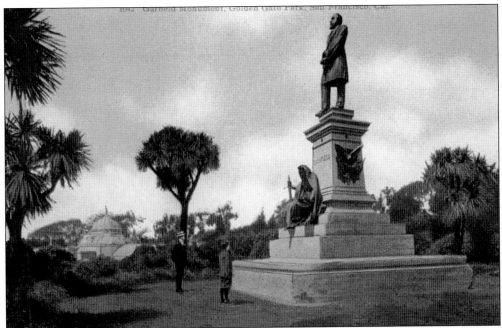

This oldest monument in the park commemorates Ohio-born James Garfield who was gunned down by an assassin in 1881 after serving only four months as U.S. president. Contributions for construction of the monument came from many local organizations, including a benefit tournament given at Bay District Park.

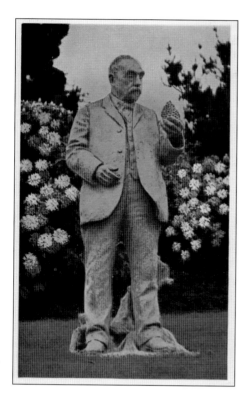

Self-described "Boss Gardener" Park Superintendent John McLaren stands on the earth he so revered, admiring a pinecone. Sculpted by park commissioner M. Earl Cummings, this statue was not put in place until after McLaren's death.

A gift of San Francisco's Scottish citizens, the Robert Burns Memorial depicts the Scottish national poet. The base, designed by San Francisco City Hall architects Bakewell and Brown, recounts Burns's poem *To a Mountain Daisy*.

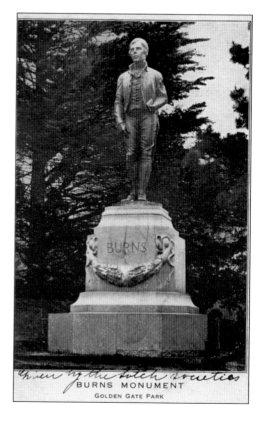

This obelisk-shaped monument to General Ulysses S. Grant was designed (and the bronze portions sculpted) by Rupert Schmid. Sadly, the massive bronze portion portraying the soldier's hat, sword, cannon, and gun, set amongst draped flags, is missing. Schmid had exhibited 10 pieces in the Midwinter Fair's Fine Arts building.

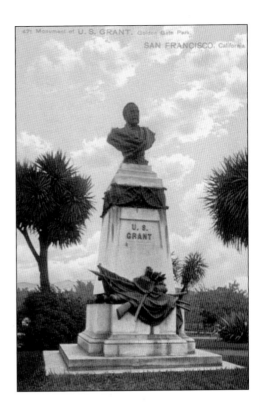

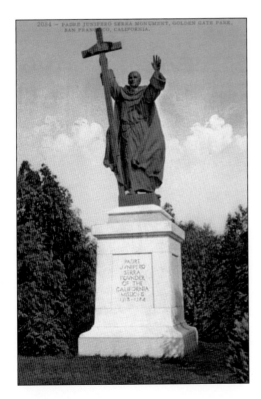

Padre Junipero Serra, the founder of California's 21 Franciscan missions, is depicted here standing upon a high pedestal. This piece was sculpted by artist Douglas Tilden with funding from Senator James Phelan.

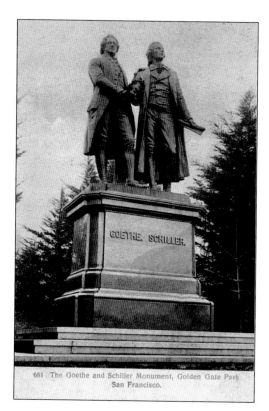

681 The Goethe and Schiller Monument, Golden Gate Park San Francisco.

June 10, 1894 was designated German Day at the Midwinter Fair, and this monument was installed to perpetuate the memory of German authors Goethe and Schiller. This large-scale work originally sat in front of what was the Asian Art Museum entrance, and was later moved to its present site next to the California Academy of Sciences.

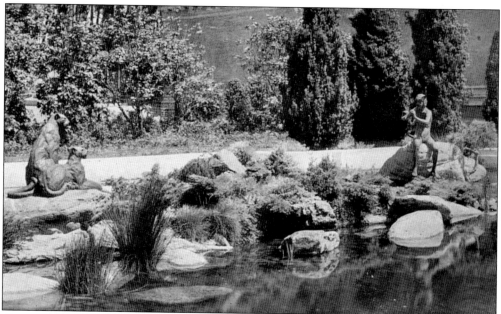

The naturalistic Pool of Enchantment sat at the front entry of the 1921 de Young Museum. Its placid waters reflected bronze figures showing a Native American boy playing pipes to a pair of California mountain lions sitting across a woodland stream. Park commissioner and artist M. Earl Cummings sculpted the pieces while architect Herbert Schmidt designed the granite pool.

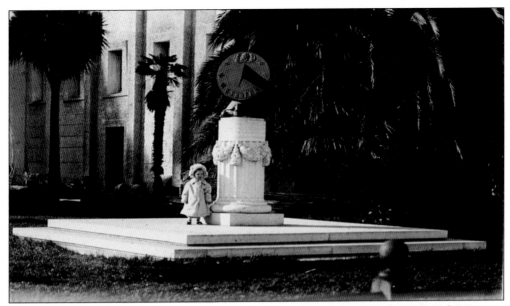

This real photo postcard shows the Sundial sitting near the original Memorial Museum building. This piece was a gift of the National Society of Colonial Dames of America in California to celebrate three navigators of California's coastline.

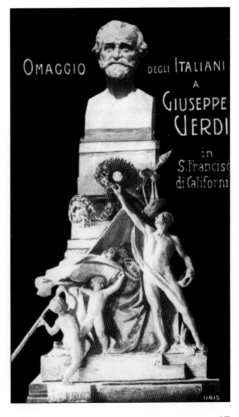

This structure seems to be the *maquette*, or original model, by artist Orazio Grossoni for the Giuseppe Verdi memorial. Honoring the Italian composer, the card and the sculpture were both made in Milan, Italy. Luisa Tetrazzini, San Francisco's favorite opera star of the time, sang an aria from *Aida* during its dedication in 1914.

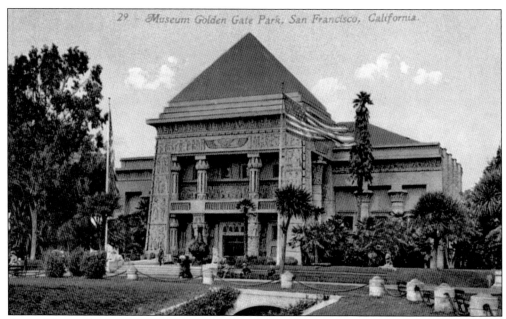

One of the park's smaller works is the Lion Statue (shown in the right-hand quarter of the postcard), which was placed in 1906. It was a gift of San Francisco jewelers Shreve and Company and sculpted by New York artist Ronald Hinton Perry.

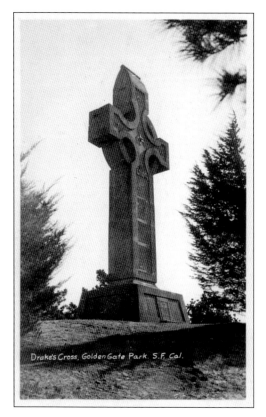

The tallest monument in the park is the 64-foot-high Prayer Book Cross. Made of Colusa sandstone, the Celtic cross symbolizes the 1579 arrival of Sir Francis Drake at Marin County's Point Reyes. At that site, a service was performed to commemorate St. John the Baptist Day.

Two

Two World-Class Expositions

Two major expositions to showcase commerce and technology were planned within the park's boundaries, but only the California Midwinter International Exposition of 1894 (commonly called the Midwinter Fair) actually took place there. The long-heralded Panama-Pacific International Exposition (PPIE) of 1915 was planned to occur in part here but was eventually held in the Harbor View area, now known as the Marina district. There was a brief but grand ceremony in 1911 where President William Howard Taft turned a spade of earth in the park's athletics stadium. Certainly Park Superintendent McLaren was relieved when the PPIE went elsewhere, after what he had experienced earlier in the way of damage and neglect by the producers of the Midwinter Fair.

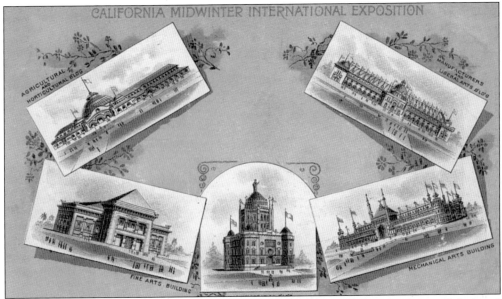

The Midwinter Fair's five major buildings faced the festival's Grand Court and were all designed differently, unlike the consistency of the World's Chicago Exhibition held the year before. Printer H.S. Crocker produced this trade card which advertised Sperry's Flour on the back.

688 Statue, Commemorating Industrial Exposition, 1893-94, San Francisco.

The Roman Gladiator statue marks the spot where the Midwinter Fair's groundbreaking ceremony took place on August 24, 1893. Remarkably, this was an ambitious schedule of four months before the fairgrounds were slated to open—consequently many exhibitor buildings were not ready until months after the official opening.

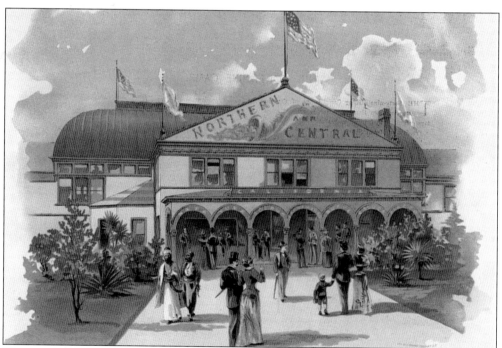

Illustrated in H.S. Crocker's souvenir Midwinter Fair booklet is the Northern and Central California Building, representing eleven counties. A three-dimensional cornucopia sculpted on the building's pediment depicts the counties' great wealth of agricultural wonders shown in the exhibit.

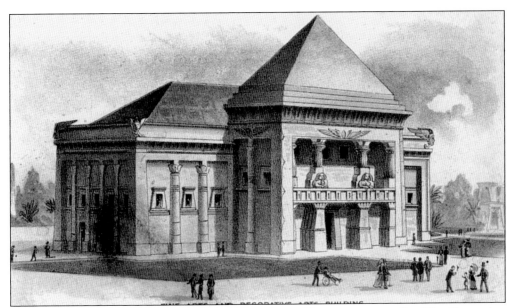

This card appears to be part of a set held together with a screw-post clip. The illustration quite broadly interprets the subject of the Fine Arts building, lacking any detail of the actual structure. It later became the Memorial Museum, the beginning of San Francisco's municipal museum system.

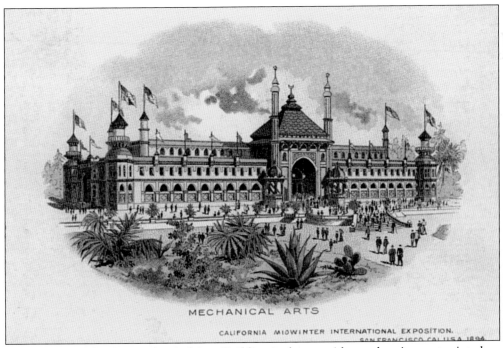

This trade card for the Mechanical Arts Building is shown with an advertisement printed on the back for Golden Gate Compressed Yeast Company, 1420 Pine Street, San Francisco—replete with recipes for white bread and buckwheat cakes.

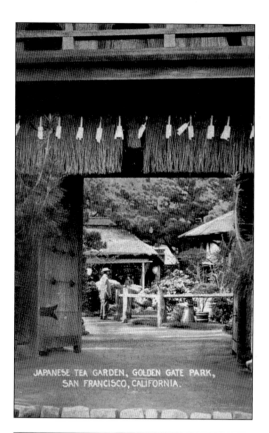

Upon entering the front gate, a visitor to the Japanese Tea Garden would view a tea house and theater for live performances.

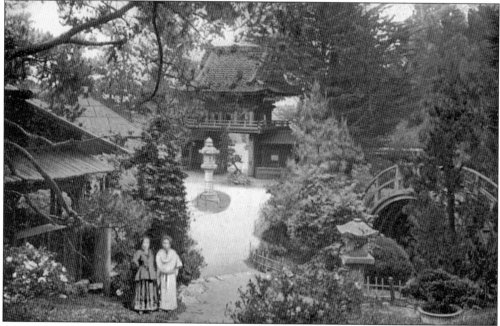

The Japanese Tea Garden (or Japanese Village as it was known during the Midwinter Fair) can be seen here, with the main entry gate in the distance.

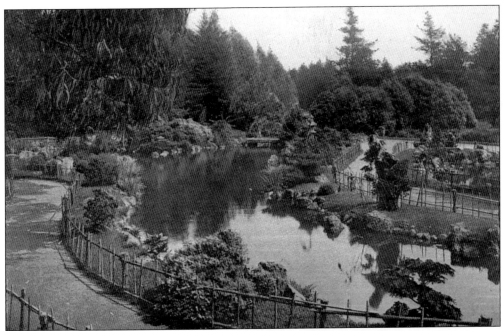

Crooked pathways in the Japanese Tea Garden make visitors walk a slow pace so they can enjoy the garden's wonders. Then as now, goldfish swam in its waterways.

This Japanese Tea Garden card was mailed in 1905 to a recipient in Denmark.

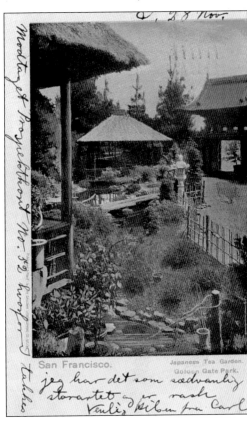

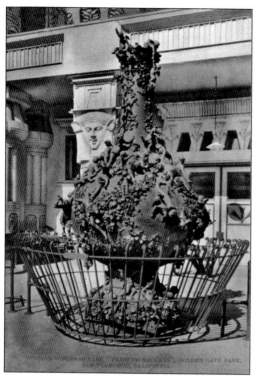

French sculptor Paul Gustave Doré created this 11-foot-high cast bronze vase sculpture, titled *The Story of the Vine*. Shown inside the Fine Arts Building, its three-dimensional exterior virtually writhes with a variety of mythological figures to tell the story of winemaking.

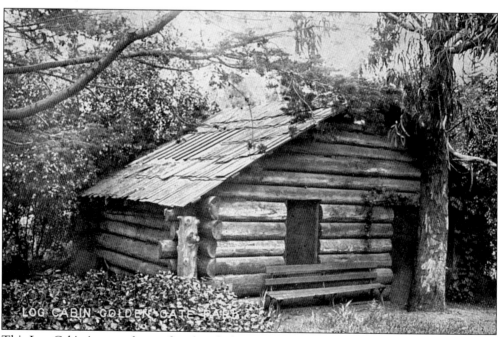

This Log Cabin is not to be confused with the extant Pioneer Log Cabin that was constructed nearby. This cabin was part of the '49er Mining Camp built to ape the simple structures that sprung up around the Sierra Nevada's Gold County. This cabin was retained after the fair as a tool shed but no longer exists.

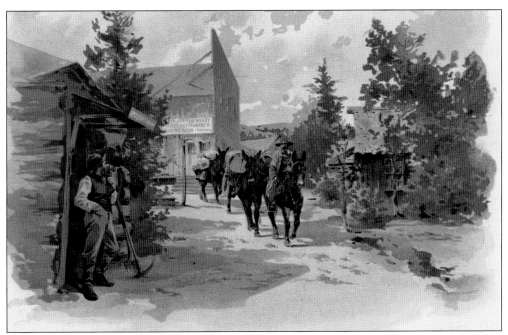

This figure is not a postcard, but rather an illustration from H.S. Crocker's Midwinter Fair souvenir booklet showing the '49er Mining Camp exhibit.

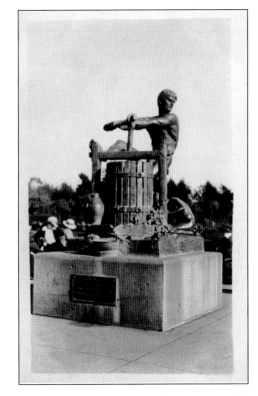

The Apple Cider Press statue was purchased by fair director Michael H. de Young from the French Commission in 1894. It sat on a highly articulated cast concrete base for the fair and was later remounted on the granite plinth seen today.

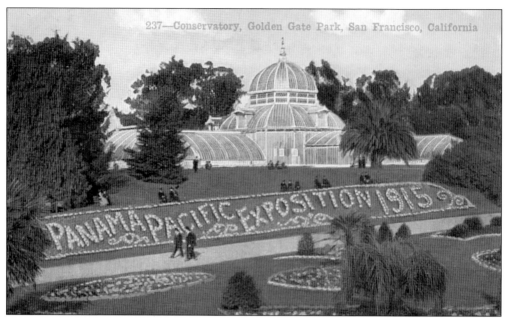

Even though the PPIE did not take place in the park, a floral plaque located in front of the Conservatory of Flowers celebrated it as visitors wandered the entire city during 1915.

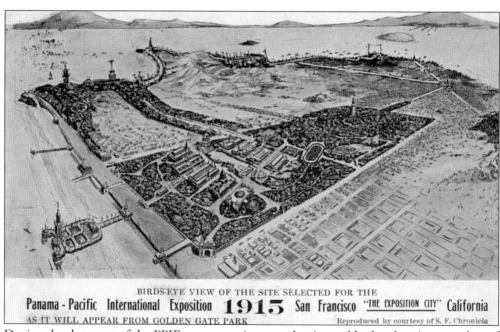

During development of the PPIE —one notion was that it would take place in a number of sites around San Francisco with the park as its nucleus. A grand pier was to be built on Ocean Beach to receive visitors arriving by sea. But the idea of a city-wide exposition was changed in favor of one site in Harbor View—none of the attractions shown here were built.

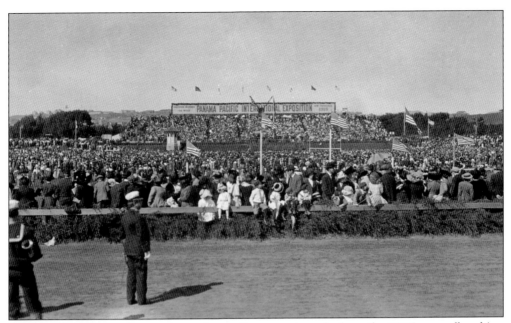

This shot looking northwest shows the stadium grandstand where the PPIE groundbreaking ceremony took place. The stadium was intended to be one of the fair's many venue spots. But after a final decision to hold the exposition in Harbor View, the scheme was scuttled.

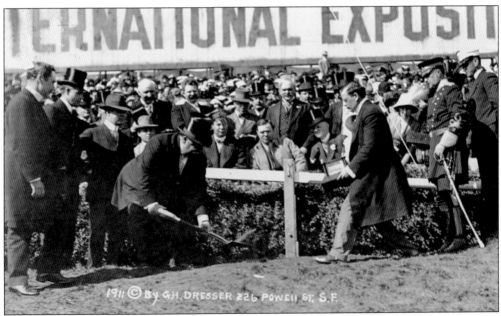

On October 14, 1911 President William Howard Taft arrived in Golden Gate Park Stadium to kick off the seminal event of the PPIE's construction, proclaiming that indeed San Francisco had arisen anew after the earthquake and fire of 1906. With the symbolic turn of a sterling silver spade he launched the city's most ambitious civic project ever undertaken and with it a pride that all citizens embraced.

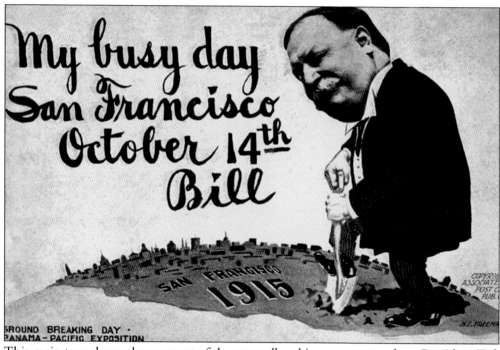

This caricature shows the moment of the groundbreaking ceremony where President Taft turns the spade of earth to launch the PPIE's construction. It took place in front of the stadium's northern side grandstands.

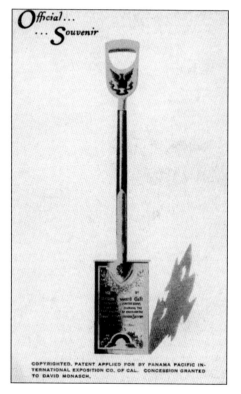

This postcard shows an image of the actual spade used by President William Howard Taft to start construction, although no final decision about the fair's site was yet at hand.

Three

ENLIGHTENMENT ON THE CONCOURSE

With the opening of the Memorial Museum in 1895, the idea of educational institutions in the park began. After all, New York's Central Park had the Metropolitan Museum of Art, so why shouldn't San Francisco follow suit? (Many other concepts seen in Golden Gate Park were borrowed from its Gotham cousin, too.) The Memorial Museum freely mixed natural history, art, anthropology and other curiosities. Some 21 years later, the North American Hall of Mammals and Birds, under the auspices of the California Academy of Sciences, opened its doors (although founded many years earlier, the academy lost its downtown home, and much of its collections to the 1906 earthquake and fire). This facility stood directly across the Concourse, and provided a chance to examine stuffed animal specimens displayed in dioramas showing their natural habitats. As the collections of the academy grew, so too did the structures—Steinhart Aquarium opened in 1923 followed by Simpson African Hall in 1934.

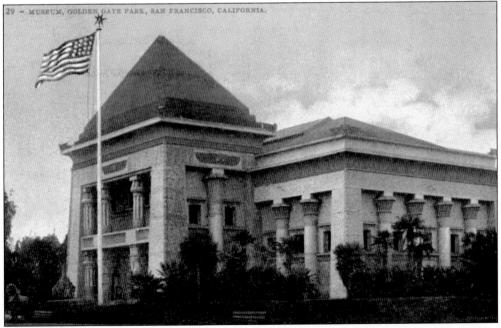

The Egyptian-style Memorial Museum opened its doors free of charge to the public in 1895. For the year 1897 a total of 471,777 visitors attended the museum.

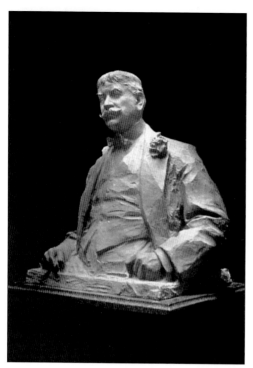

The formidable Michael H. de Young was the founding benefactor of today's Fine Arts Museums of San Francisco. Inspired by his own eclectic collections, de Young sought to create a diverse series of exhibits. This sculpture depicting de Young was sculpted by Rodin follower Paul Troubetzkoy, son of a Russian nobleman.

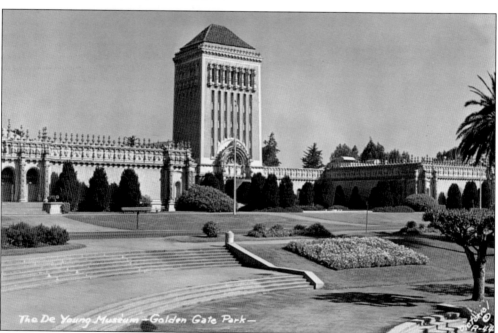

The Memorial Museum was formally dedicated in 1921 after its various parts, built over a four-year period, were completed by contractor Albert Swinerton's Lindgren Company. Designer Louis Christian Mulgardt styled the decorative salmon and crème-colored exterior based on a previous commission of his, the *Court of Ages*, built for the Panama-Pacific International Exposition.

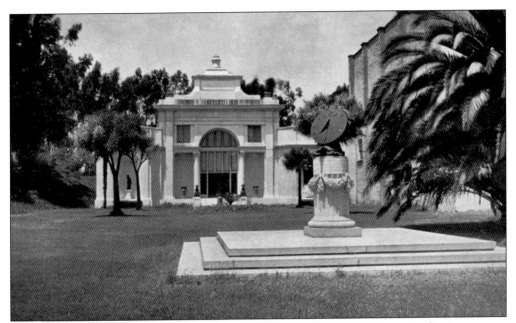

The Royal Bavarian Pavilion was built to house three sumptuous reproduction rooms simulating those of King Ludwig of Bavaria's royal palace in Munich, Germany. The German government constructed these for the Chicago Columbian Exposition and then reused them in the Midwinter Fair. This building was constructed after the Midwinter Fair to house the European works.

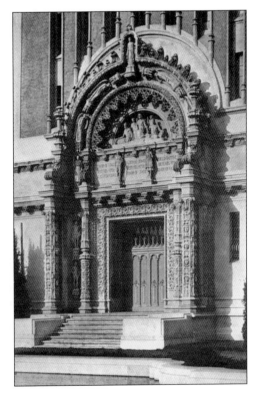

The Memorial Museum's main entry portal was sculpted by Leo Lentelli. Artist Haig Patigian did the inset half-round tympanum of figures depicting Knowledge, Science, Industry, Education and History.

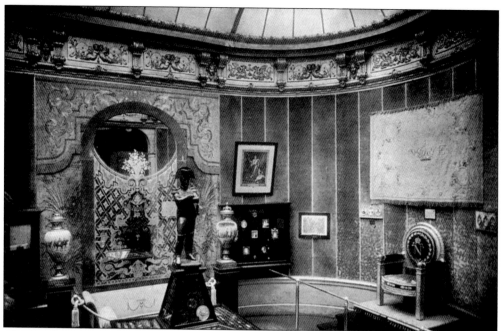

The Napoleon Room, part of the Royal Bavarian Pavilion, housed relics of the Corsican Emperor Napoleon. In April of 1895 over two dozen valuable Napoleonic medals were stolen from the square display cabinet topped by a figure of the emperor.

This card depicts one of three rooms from the Royal Bavarian Palace; the luxurious finishes included damask brocade covered walls, a vaulted ceiling with frescoes and elaborate wood marquetry door frames.

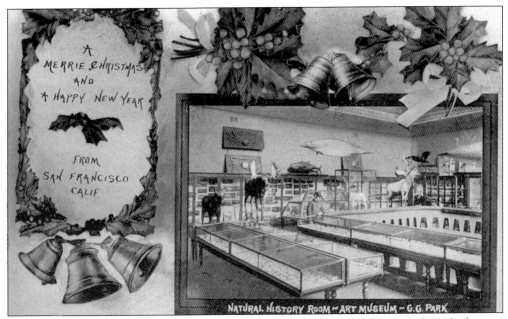

Originally the Memorial Museum housed some items of natural history which had come from the collections shown in the old Casino, which once sat near the conservatory. These two cards, which were initially blank within the frame, were filled in with illustrations of the museum for final reproduction.

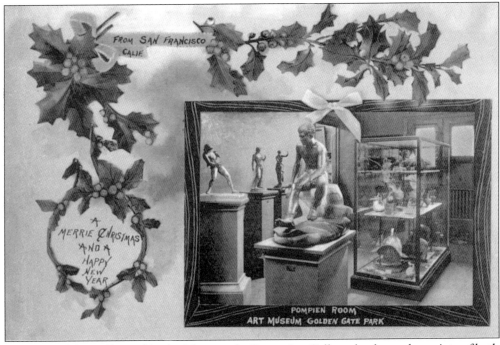

A section of the Gallery of Antiquities was the Pompeian Gallery that housed a variety of both real and reproduced pieces from the ancient lost town of Pompeii, Italy.

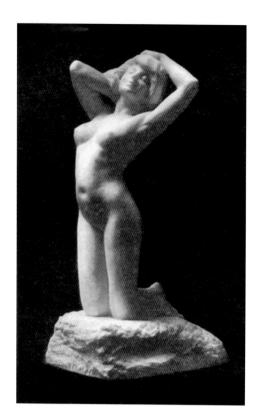

A song of praise is celebrated in this marble sculptural tribute titled *Hymn* by artist Alice Nordin. It was uncommon for a woman artist to be working at this time.

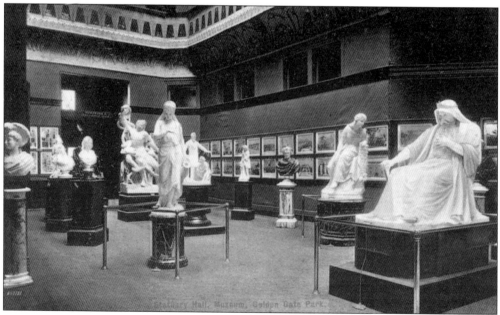

Statuary Hall occupied the main entry hall of the original Egyptian-styled Memorial Museum. *King Saul* is shown on the right and *The Emancipation Proclamation* is at center.

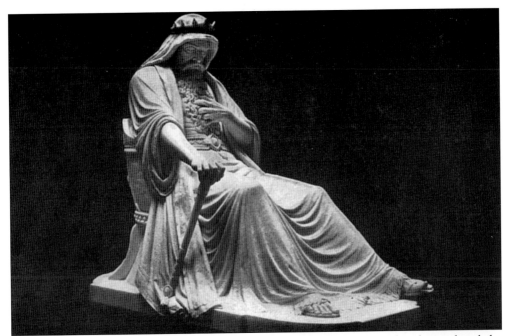

King Saul was an 1897 gift of Mayor Phelan. William Wetmore Story, who also sculpted the Francis Scott Key Monument's bronze portions, sculpted this immense work in 1882 from a single block of white Carrara marble. This piece remains in the city's museum collection.

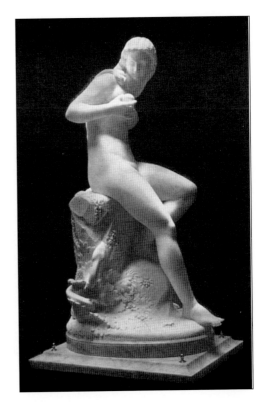

Capturing Eve sitting among greenery of the forest, sculptor O. Andreoni shows her holding the symbolic apple. She has just plucked the fruit from the Tree of the Knowledge of Good and Evil. Nearby a serpent lurks among the flowers.

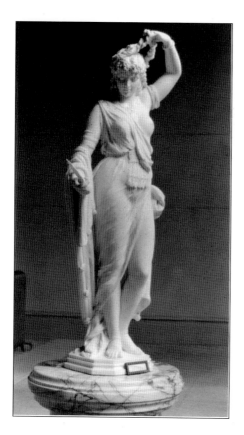

The allegorical *Vanity* raises her locks as she strikes a prolonged pose to examine herself in a hand-held mirror. The symbolic work serves to remind the viewer that conceit is sinful.

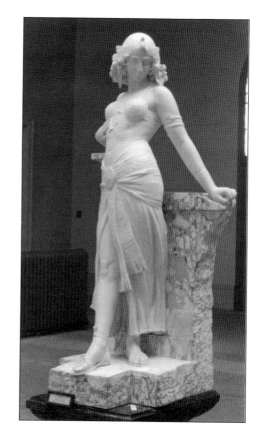

Salome, whose dance was a death knell, was posed by Mary Garden. Sculptor G. Ganboge created the piece using white marble on a pedestal of contrasting veined marble.

Sculpted by T. Ball of white Carrara marble, *The Emancipation Proclamation* symbolically shows a slave unshackled by President Abraham Lincoln. A gift of George Crocker, the piece was small, only about 30 inches high.

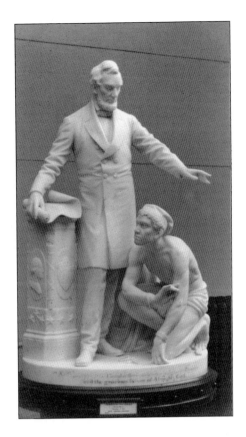

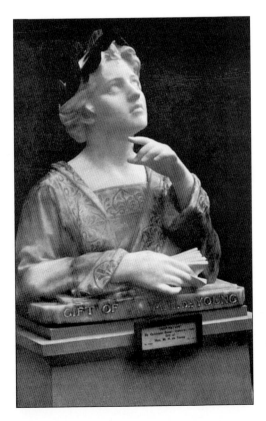

White stone combined with brown-veined marble makes *Inspiration* an unusual piece. It was sculpted by Giuseppe Bessi of Veiterra, Italy and was a gift of M.H. de Young.

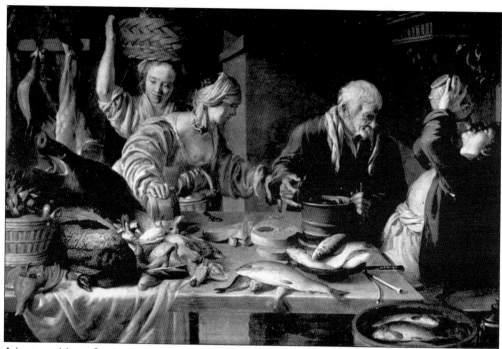

A juxtaposition of active people among edible still life is the hallmark of *The Holland Fish Market* by Francois Gerard. The work was a gift of Maud I. Pettus.

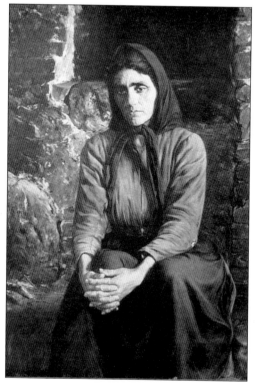

Another oil painting, *The Widow* by A. Birelli, is also catalogued as having been in the collection in 1921. It shows an Italian peasant woman sitting forlorn by a fire hearth.

A dramatic scene takes place in Jules Mongue's oil painting titled *Last of the Battalion*. A soldier writes his last words among the ruins of a battle.

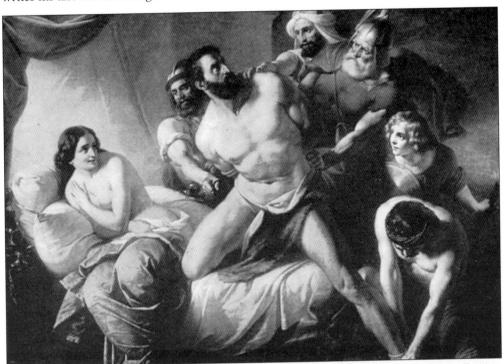

Paul Emile Jacobs' *Samson and Delilah* is catalogued as having hung in the museum's collection upon the opening of the 1921 building. Painted in 1845, it was brought to San Francisco soon after and was saved from the 1906 fire.

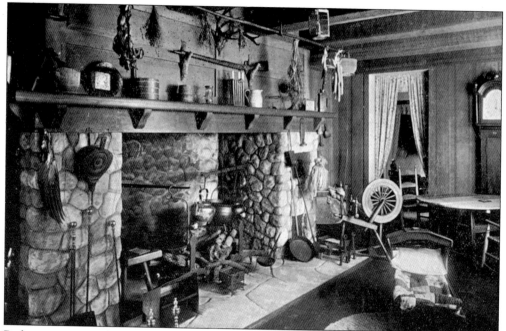
Perhaps to prompt them not to forget their roots, visitors saw period rooms such as the Colonial Kitchen that served as a reminder of the hardships their forebears endured. An adjacent bedroom, a assortment of household objects, and ephemera complemented the exhibit.

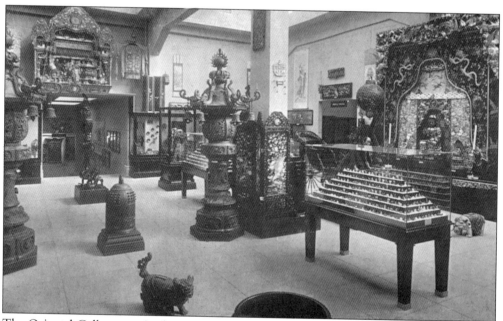
The Oriental Gallery was in the east wing of Mulgardt's 1921 building, which was the first section to be built. Today some of these objects might be found in the recently moved Asian Museum collection.

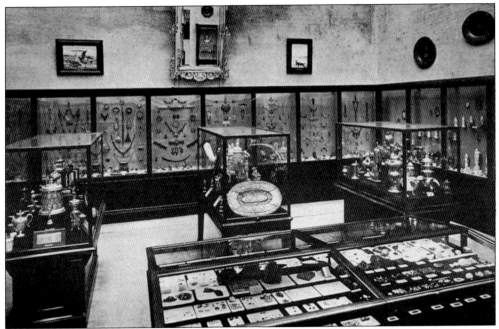

The de Young's Jewels and Objects of Art room looks more like a crowed retail sales room than a museum display, at least by today's art display standards.

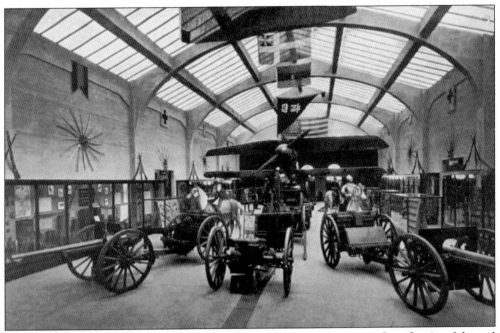

With World War I still burning in people's memories, a visual history of warfare is celebrated in the Arms and Armor Gallery. Taking up the whole central spine of the western portion of the de Young, a German World War I plane shot down by Allies hangs above.

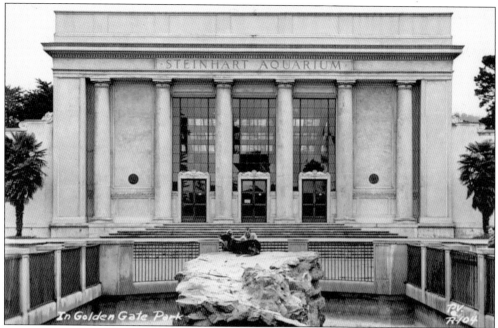

Across the Concourse from the de Young is the California Academy of Sciences, with Steinhart Aquarium as its entry. Opened in 1923, the building's construction was funded by brothers Ignatz and Sigmund Steinhart. A triple grouping of recessed pits punctuated the original exterior courtyard, the central one used to display live harbor seals.

Jenkin's scorpionfish, or nohu omakaha, was initially named for two academy members Jordan and Evermann. This is a poisonous fish that ranges from 12 to 20 inches.

42

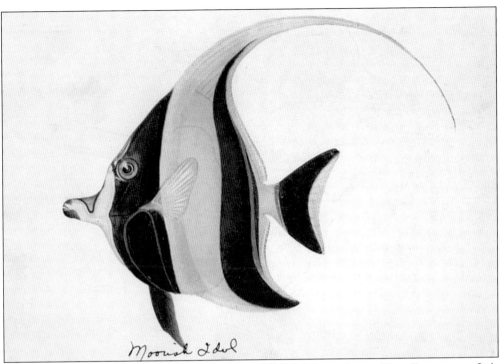

The dramatically contrasted Moorish devil, or kihikihi, is native to Hawaiian waters. It is popular in aquariums today.

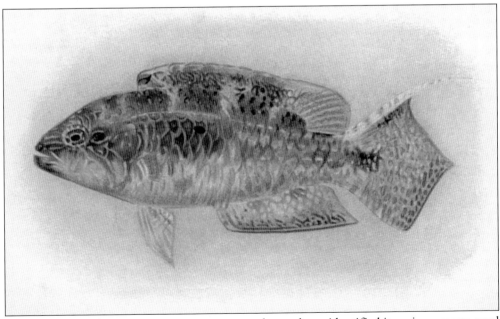

A brightly colored two-spot wrasse, or poou as the academy identified it, swims among coral reefs of the Hawaiian Islands. It grows to 5 inches in length.

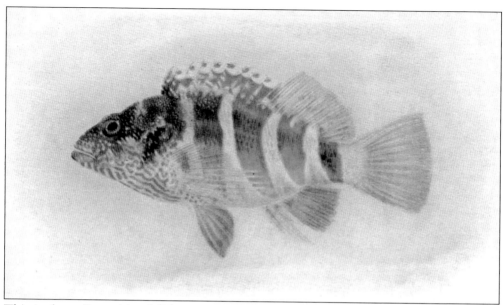

This is the redbarred hawkfish, or oopuka-hai-hai, as this Steinhart Aquarium postcard denotes it.

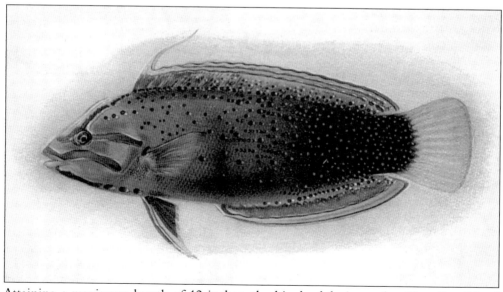

Attaining a maximum length of 12 inches, the hinalea lolo is another Hawaiian Island coral reef fish.

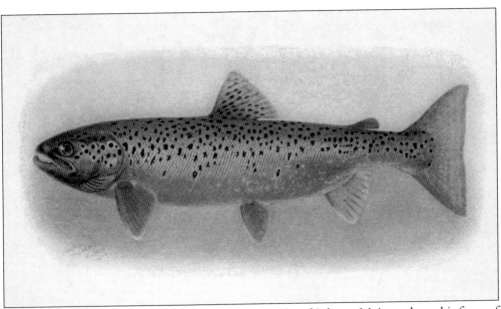

Sebago salmon gets its name from the land-locked lake of Sebago, Maine, where this form of Atlantic salmon hails. But it was later discovered elsewhere as well.

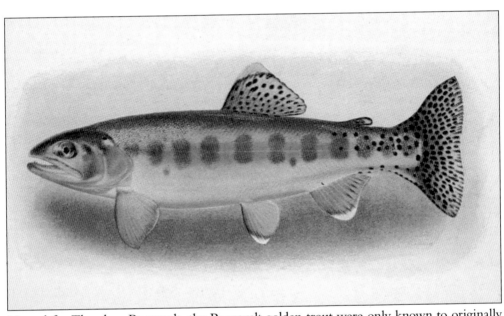

Named for Theodore Roosevelt, the Roosevelt golden trout were only known to originally exist in Volcano Creek near California's Mt. Whitney. Academy of Sciences member Barton W. Evermann was responsible for naming this fish.

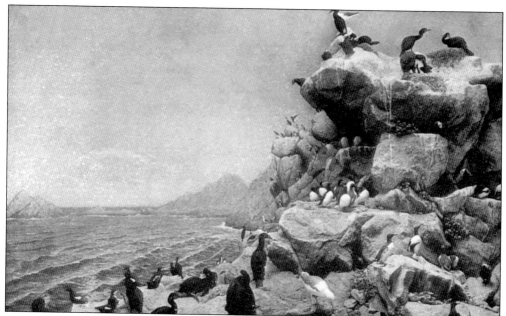

William H. Crocker presented this exhibit known as the Farallon Islands Bird Rookery, sporting ten species of sea birds and one land bird. Several members of the Crocker clan are recorded to have participated in academy history.

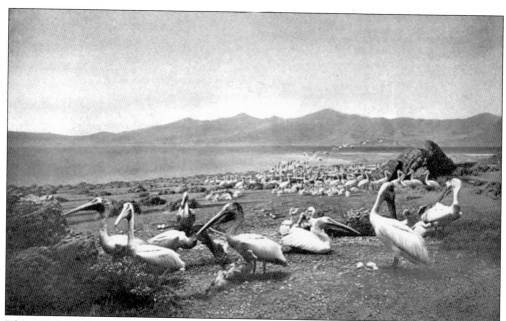

This White Pelican Habitat Group was donated to the academy by A.K. Macomber. The background diorama is an impression of the conditions on Anaho Island in Nevada's Pyramid Lake.

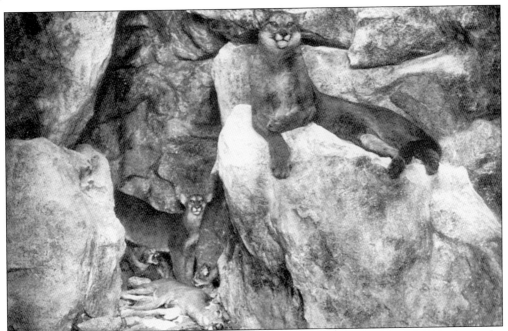
A representative Mountain Lion Group is shown in its native habitat of a protective rocky cave, complete with a bountiful catch.

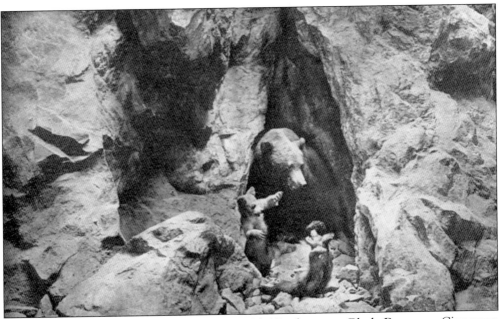
This diorama shows off the taxidermist's art with Northwestern Black, Brown, or Cinnamon Bear group, shown as a family group.

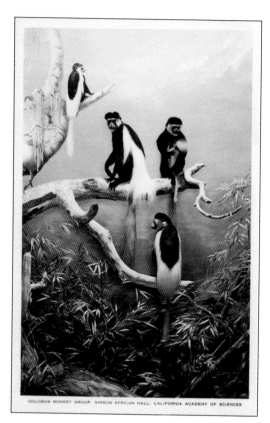

Shown in the academy's Simson African Hall is this diorama of a Colobus Monkey Group. The tree-top dwellers were once sought for their fur used in fashion.

COLOBUS MONKEY GROUP, SIMSON AFRICAN HALL, CALIFORNIA ACADEMY OF SCIENCES

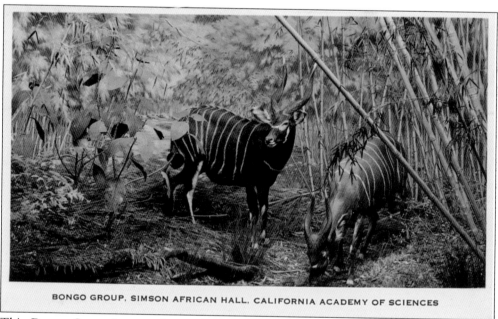

BONGO GROUP, SIMSON AFRICAN HALL, CALIFORNIA ACADEMY OF SCIENCES

This Bongo Group is one of several dioramas in Simson African Hall. Donor and San Francisco native Leslie Simson, a mining engineer and sportsman, graduated from the U.C. Berkeley Mining School in 1901.

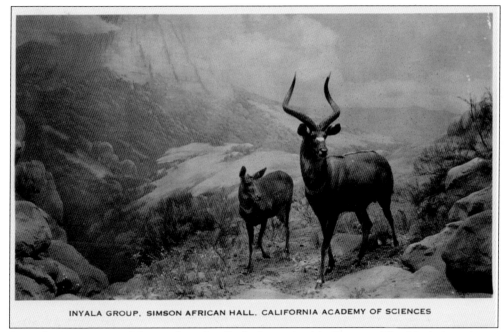

INYALA GROUP, SIMSON AFRICAN HALL, CALIFORNIA ACADEMY OF SCIENCES

A Nyala Group, part of the antelope family, is shown in this diorama. The Nyala is native to the Mendebo Mountains of Ethiopia.

Another diorama is the Hunting Dog Group, showing a dog that is quite similar to domesticated dogs but has only four toes on the forefeet instead of five.

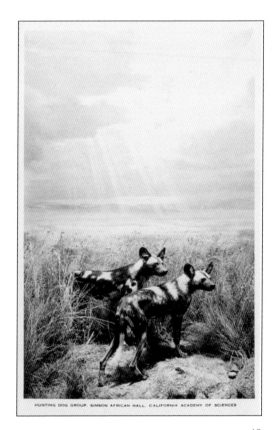

HUNTING DOG GROUP, SIMSON AFRICAN HALL, CALIFORNIA ACADEMY OF SCIENCES

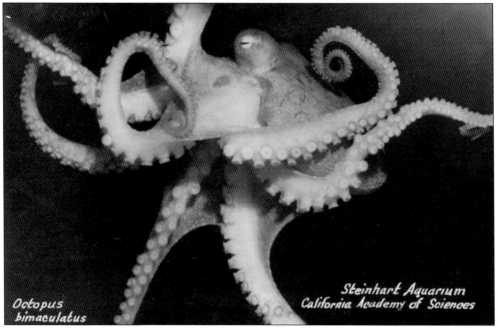

Octopus bimaculatus, in action at the Steinhart Aqaurium. A specimen of an eight-arm octopus is shown in this real photo issued by the academy.

The Morrison Planetarium projector was built by the Academy's own optical repair shop and debuted in 1952 after four years of labor. Weighing some 5,000 pounds, it contains about 25,000 separate parts.

Four

RECREATIONAL PASTIMES

A wide assortment of sports, hobbies, and games were always under way in the park. Initially, there was little planned for such a wide variety of activities since sports as we know them today were just getting a foothold then as part of the social curricula. The park's original master plan called for a picnic area, botanical garden, conservatory, flower gardens, lawns, children's playground, concert pavilion, and a good quantity of lakes and drives. But just as the park was being built, athletic pursuits (mostly aimed at men and boys) started to become a part of the popular American consciousness. So, in addition to the passive acts of strolling, picnicking, card or board games, and model boat sailing came other active sports. These included tennis, baseball, horse and car racing, polo, football, soccer, archery, and eventually golf.

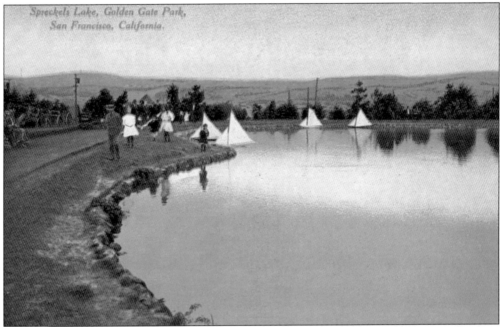

Model yacht boating on Spreckels Lake was—and still is—a pastime enjoyed by both young and old alike. The lake was created in 1904 exclusively for this purpose since there were conflicts with boaters and fly casters sharing Stow Lake.

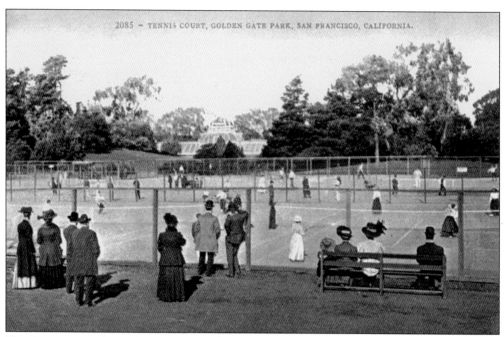

Tennis came to the park in 1901, with installation of eight standard courts plus two for children, all paved in clay. The site was home to the Francis Scott Key monument and second bandshell at one time. Croquet was once played there as well.

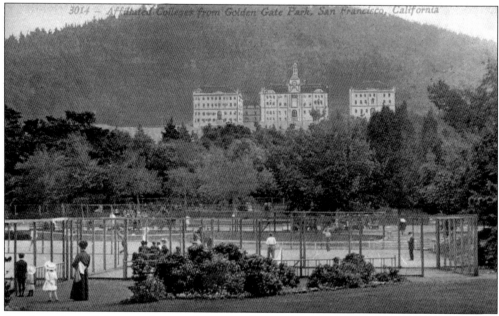

Another view of the popular tennis courts shows the Affiliated Colleges on the distant Sutro Forest hillside. The college site eventually became today's University of California Medical Center.

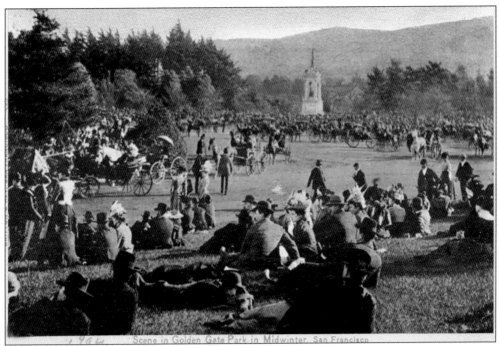

Looking south across Main Drive (now JFK Drive) this is likely a scene taken during a concert at the park's second bandshell. The shell was located where today's tennis clubhouse stands.

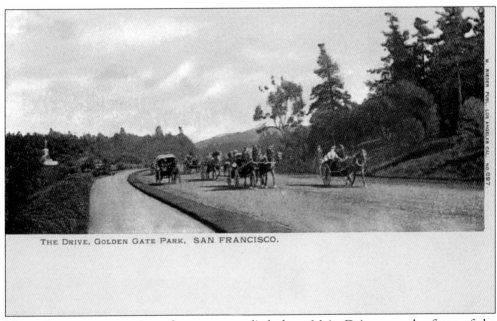

Horse-drawn transportation of many sorts plied along Main Drive near the front of the Conservatory of Flowers. The James Garfield monument sits in the distance to the left.

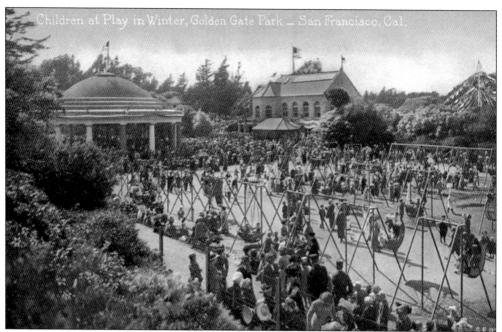

Hordes of children and their parents crowd the Children's Playground, perhaps celebrating May Day, a huge event for many years.

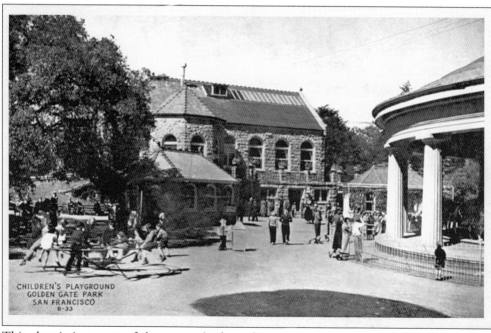

This shot is just west of the carousel where there was a far-smaller circular ride to thrill youngsters. The Sharon Building is visible in the background.

MAJOR BARBARA

by GEORGE BERNARD SHAW directed by DENNIS GARNHUM

"*IMMENSELY ENTERTAINING!*
A comedy of manners that skewers upper-class pretensions and lower-class dishonesty."
— SAN FRANCISCO CHRONICLE

After 16 years, A.C.T. brings Shaw back to the stage with a sumptuous production of one of his most rich and witty works. Salvation Army Officer Major Barbara is perplexed and disillusioned when her struggling church accepts money from her estranged father—a wealthy munitions manufacturer. The church's new wealth is the poor's ticket to salvation, but was it God or 'gunpowder' that made the difference? Timely and topical, Shaw's intriguing tangle of morality is a devilishly funny satire exploring themes of business, faith, family, and philanthropy. Coproduced with one of A.C.T.'s favorite Canadian collaborators, *Major Barbara* will be directed by Theatre Calgary Artistic Director Dennis Garnhum and features an international cast of both Canadian and American actors.

JAN 8–FEB 2
ACT-SF.ORG / 415.749.2228
GO ONLINE FOR TICKETS, SPECIAL EVENTS, AND MORE!
415 GEARY STREET, SAN FRANCISCO
GROUPS OF 15+, CALL 415.439.2473

SEASON PARTNERS

SPECIAL OFFER
$45 Orchestra Seats | $35 Mezzanine Seats
Use code **CLASSIC** when ordering*

*Subject to availability. Limitations apply. Not applicable to previously ordered tickets. Offer ends Jan 14

Ms. Cynthia Fleig
4135 19th St
San Francisco, CA 94114-2422

A.C.T.
30 GRANT AVE, SF, CA 94108-5834

NONPROFIT ORGANIZATION
U.S. POSTAGE PAID
PERMIT No 8894
SAN FRANCISCO, CA

JAN 8–FEB 2

MAJOR BARBARA

A COPRODUCTION WITH THEATRE CALGARY

WRITTEN BY
GEORGE BERNARD SHAW

DIRECTED BY
DENNIS GARNHUM

"ELEGANT, ELOQUENT, AND VERY FUNNY."
—THE NEW YORK TIMES

A.C.T.
AMERICAN CONSERVATORY THEATER
2013–14 SEASON

SAN FRANCISCO'S PREMIERE NONPROFIT THEATER COMPANY

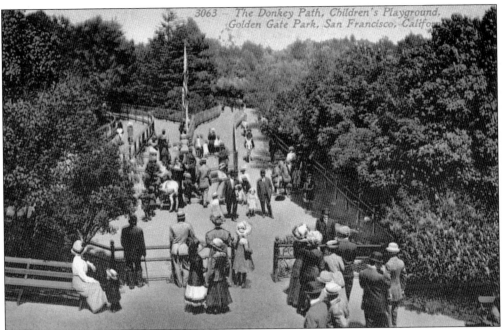

The Donkey Path gave urban children the opportunity to ride live animals. Carts pulled by goats were also available.

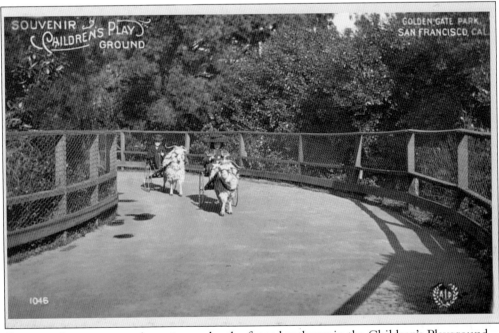

Goats towing passengers in carts wander the fenced pathway in the Children's Playground.

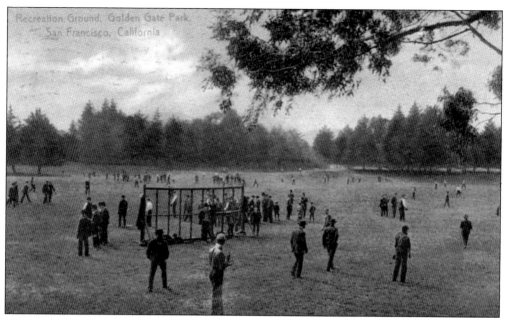

Big Rec was used as a recreation field during the Midwinter Fair and was developed most likely because the Olympic Club quarters sat across Lincoln Way. Initially it had an oval track with bleachers against the north hill. The Olympic Club is the city's premiere and oldest venue for sport and exercise (originally open only for men).

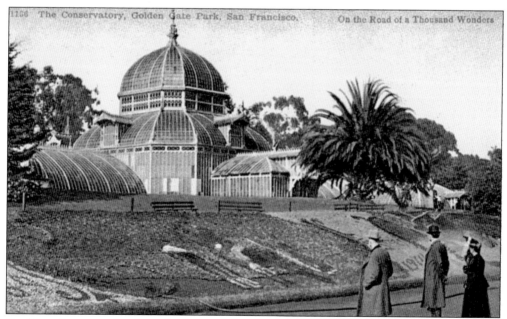

Strolling the expansive lawn in front of the Conservatory of Flowers, visitors could view a wide variety of artistic expressions rendered in landscaping. Elaborate displays welcomed large organizations, special events, or commemorated holidays. This one shows a portion of the 300-foot-long picture celebrating the Portola Festival of 1909.

Illustrating a sunny afternoon in the Music Concourse, two early 20th century women stroll amongst verdant greenery. The pathway leads to a variety of tunnels separating foot traffic from risky roadway traffic above.

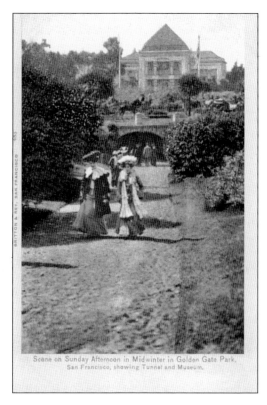

Scene on Sunday Afternoon in Midwinter in Golden Gate Park, San Francisco, showing Tunnel and Museum.

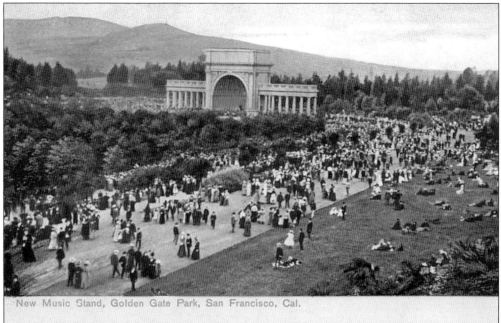

New Music Stand, Golden Gate Park, San Francisco, Cal.

Spreckels' Temple of Music, the third bandstand in the park, still stands today as a daylight venue for live musicians, opera, and dance. Here thousands crowd Concert Valley (today called the Concourse) during what probably was a weekend concert.

57

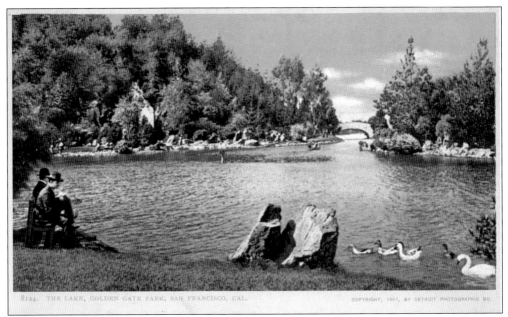

With the Roman Bridge arching over Stow Lake in the distance, boaters oar lazily around the circular lake.

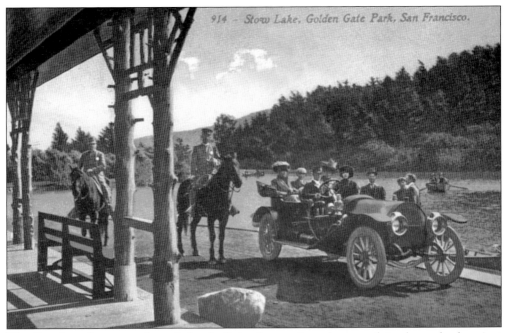

The first boat house on Stow Lake, built in the rustic style, served in the early days just as it does today. But then, only rowboats were for hire to lazily explore the lake's circular waterway bound by curvilinear shoreline. Today, there are also electric powered boats and foot-propelled paddle boats.

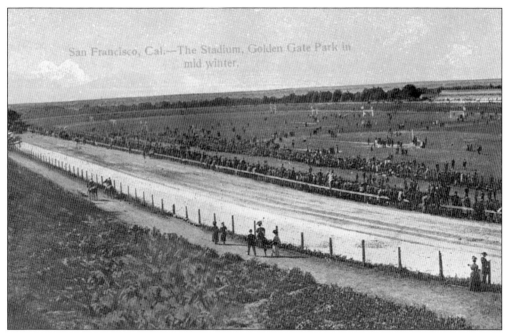

Golden Gate Park Stadium was the scene of many athletic gatherings including bicycling, polo, football, cricket, and horse riding. It was dedicated in 1906 as the largest athletic venue in the park.

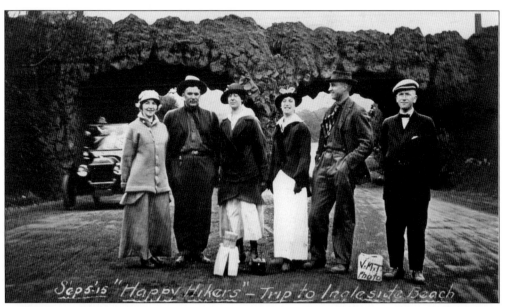

Dated September 5, 1915, a group of "Happy Hikers" were captured in this real photo next to the rustic stone railway overpass located adjacent to the Murphy Windmill. The group appears to have been on their way to or from Ingleside Beach.

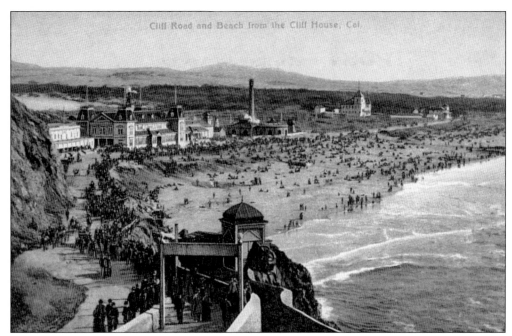

At the western end of the park lays the grand Pacific Ocean. The previous entertainment facilities from before the Playland-at-the-Beach era sit to the left, while the still unlandscaped park is on the right.

A close-up view of the beach shows the U.S. Life-Saving Service station on a festive crowded day, perhaps a weekend. Note the flags flying to the east signaling the persistent afternoon onshore breeze.

Five

WATERY DELIGHTS

It seems ironic that water features such as lakes, ponds, and waterfalls should now occur within what was considered a desert prior to its cultivation. Known in the early days as the "Outside Lands," the area had few natural watering places—most of those seen today are by the hand of humans. It is especially striking when you realize that the waterfalls require mechanical re-circulation to perform their aesthetic magic. From 1872 to 1873, a daily quantity of 100,000 gallons of water was purchased from the Spring Valley Water Company to green the young landscape. Over time, water sources in the park were found, thereby mitigating the cost of purchasing the precious lifeblood. Wells were sunk in the vicinity of the arboretum and later near Ocean Beach. But one water feature is natural, the largest, and the most dramatic of all: the Pacific Ocean bordering the park's entire western end, complementing Golden Gate Park's unique series of beautiful vistas.

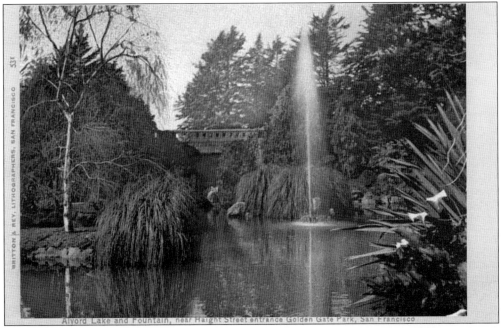

A lake was created in 1882 and later improved, in 1894, with money from William Alvord, the park commission president. Alvord wanted it named "The Lakelet" but others asked that its benefactor's name be used.

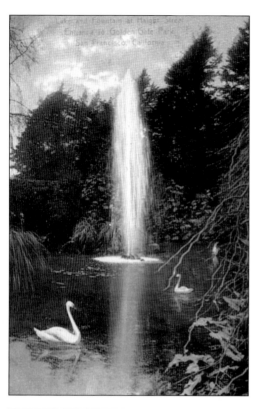

Alvord Lake's undulating shoreline and dense foliage provided a tranquil home for swans and other waterfowl.

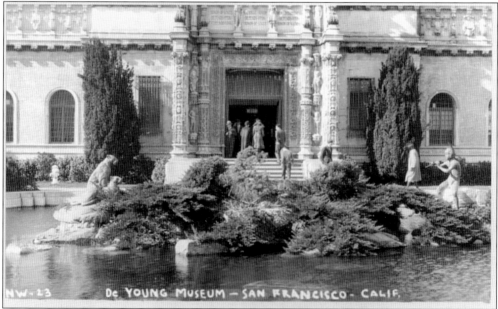

The Pool of Enchantment was funded by Maria Becker to memorialize her husband Bernard. Originally she hoped to build an observatory to replace the one which sat on top of Strawberry Hill until the 1906 earthquake destroyed it. This pool, with its bronze figures, became the alternative when park commissioners nixed Becker's original proposal.

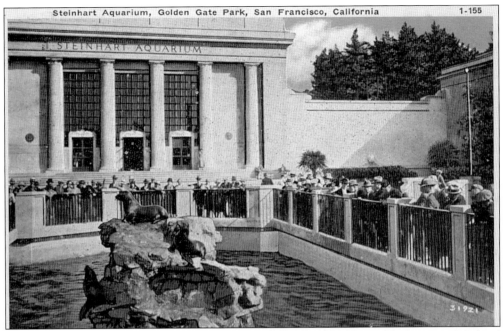

Live seals cavorted in the courtyard pool of the Steinhart Aquarium. Their antics delighted visitors of all ages.

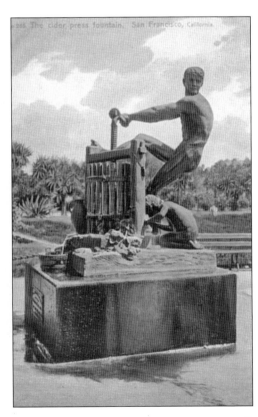

The Apple Cider Press sculpture doubled as an artistic object and a drinking fountain.

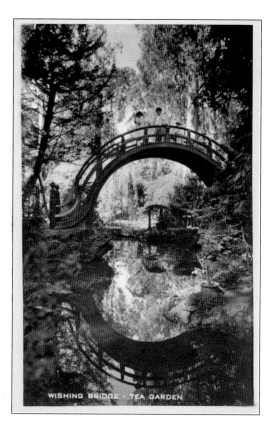

The Moon Bridge (or Drum Bridge as some people know it), arches over tranquil waters of the Japanese Tea Garden. Its shape is deliberately designed to slow visitors down so that they will take in all the garden's many vistas.

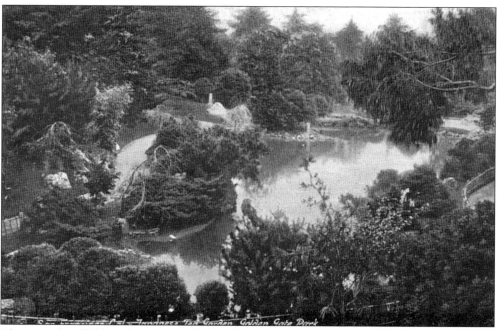

The craze for all things Japanese, including the Japanese Tea Garden, came about when trade relations between Japan and the West opened in 1853.

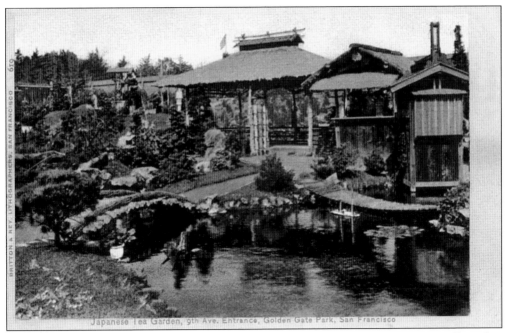

Thatched roofs, bamboo, and arched wooden bridges create a special atmosphere reflected in the Japanese Tea Garden's waters.

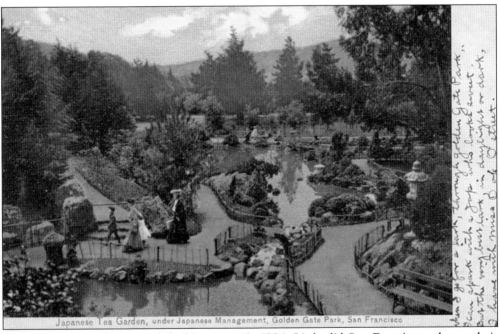

This early postcard is postmarked January 12, 1906. Little did San Franciscans know their lives would be forever changed a few months into the future.

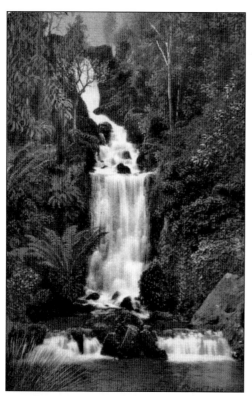

A roar of water cascades down the artificial Huntington Falls that was created through the munificent gift of Collis P. Huntington. John McLaren got the idea to create a waterfall in the park on a trip to the Sierra Nevada Mountains.

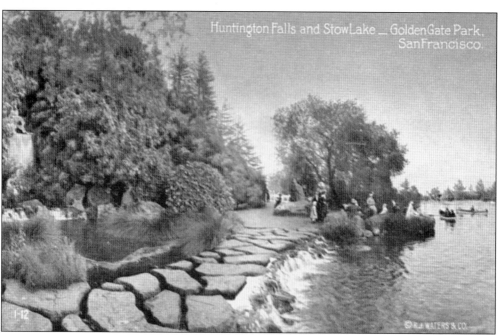

Large flat artificial stones dot the base of Huntington Falls, allowing visitors to step among the foaming water of the cataract's bottom without getting wet. A 1914 guide published by the city's chamber of commerce states that quail and rabbits were in abundance here.

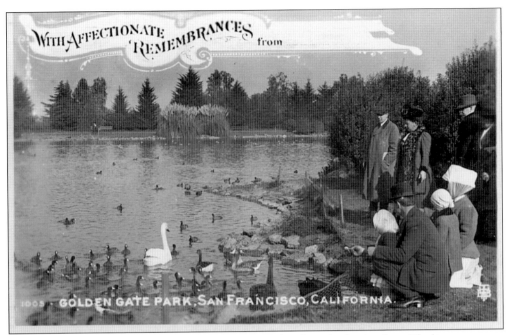

Waterfowl of many types have occupied Stow Lake since its beginning. Black swans once graced its waters where a variety of ducks and other waterfowl hold sway today.

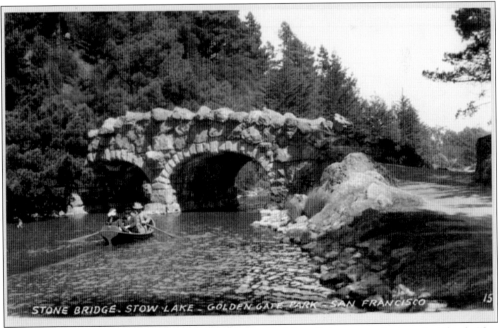

Gigantic stones make up the facings on this arched bridge. One postcard states that this bridge collapsed in the 1906 earthquake but there is no evidence to support that claim.

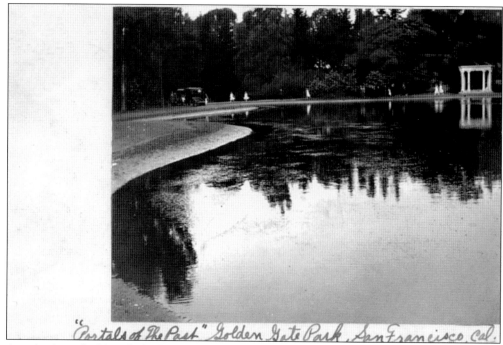

A gathering of white-clothed girls cavort along the shore of Lloyd Lake near Portals of the Past. This body of water was also known as Mirror Lake.

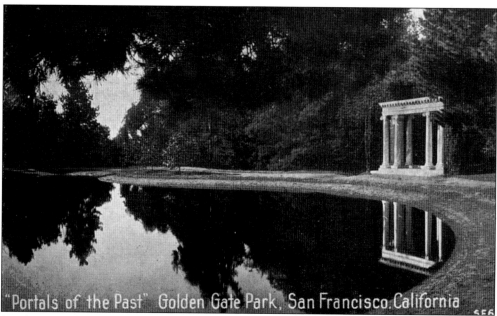

Sited across Lloyd Lake from the main viewing spot on Main Drive, the enigmatic Portals of the Past can be seen reflected in this card. Vertical Irish yew bushes flank the monument.

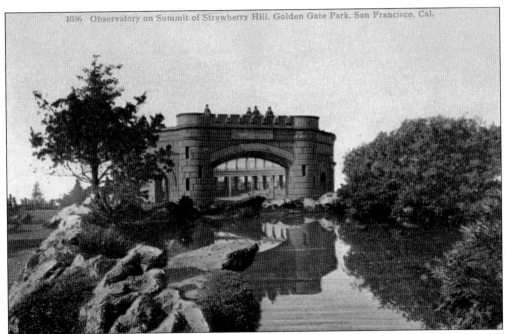

The Sweeny Observatory atop Strawberry Hill is reflected in a large artificial pond. The water feature is now dry, but races once ran down the hill to meet up with Huntington Falls.

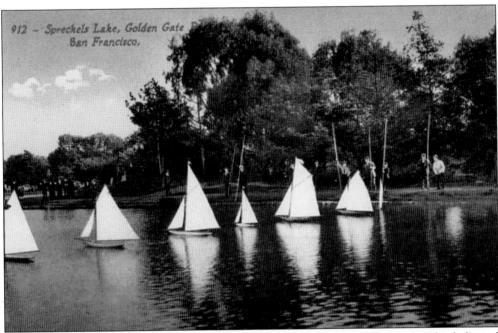

Perfectly scaled miniature boats are the equipment for sport sailing on Spreckels Lake dedicated in 1904. It was for the specific use of the San Francisco Model Yacht Club, founded in 1898.

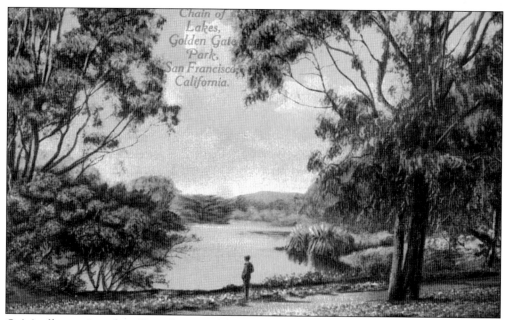

Originally a series of small pools created from underground seepage, the triple lake cluster of the Chain of Lakes were gradually sculpted into today's form.

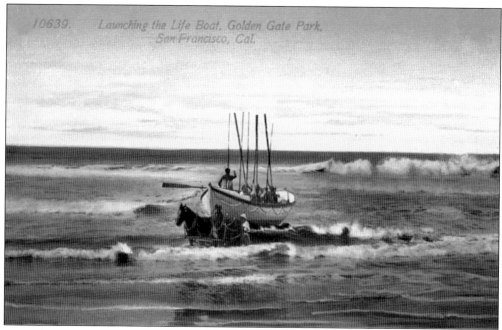

Surfmen drills were an exercise done by members of the U.S. Life-Saving Service to keep the servicemen in shape. It was arduous work to wheel the boat over sand and get it launched in the dangerous surf. Crowds often gathered along Ocean Beach to watch.

Six

Now Gone

It can be easy to wax nostalgic about various things lost to the past, and portions of Golden Gate Park are no exception to this rule. The park has seen many structures, statues and other items come and go over time. The actions of function and fashion have played a role, as has neglect—all contributing to change. Despite this constant change, the park retains an anachronistic view to its Victorian past. There were once many more residential structures in the park since most staff who maintained the park lived there; this practice is generally frowned upon today in municipal parks. Rustic-style picturesque bridges and gazebos once dotted the park's acreage but were constructed out of unpeeled bark logs whose delicate material succumbed to decay. The decline also includes wildlife that probably receded in part because of toxic chemicals on the grounds. Quail, for example, were once here in abundance but are now just a few live in Strybing Arboretum's gated enclosure. Happily, some of the things shown have survived to be relocated elsewhere.

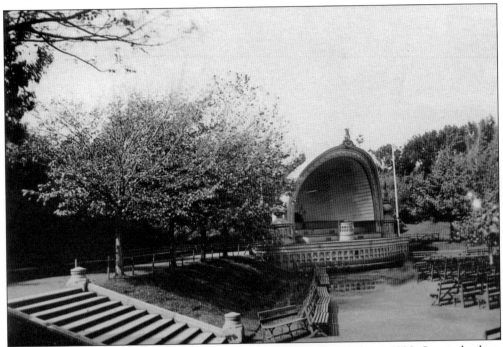

This was the park's second bandstand that was dedicated on July 4, 1888. Located where the tennis clubhouse stands today, it was designed by architects Percy and Hamilton as a decorative shell-shaped structure reflecting music toward the audience below.

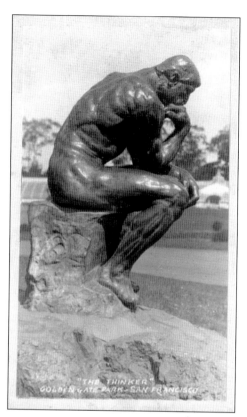

The Conservatory of Flowers stands as a backdrop to Rodin's *The Thinker*, which was installed on Favorite Point in 1916. Alma de Bretteville Spreckel's proposal to locate the piece in the emerging Civic Center failed, so she funded construction of the California Palace of the Legion of Honor to showcase the important sculpture.

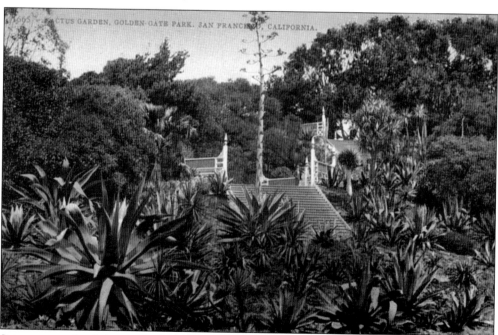

Set amongst the Arizona Garden were the Golden Stairs, a Z-shaped wooden stairway that cascaded down the hill. Painted blue, its octagonal-shaped landing was lined with seating.

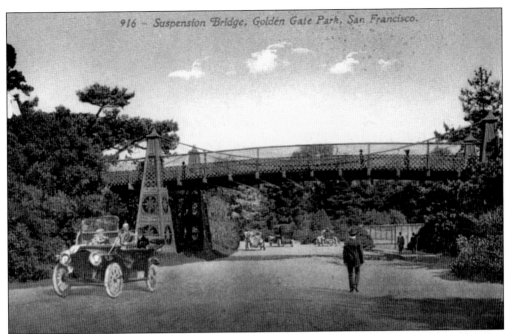

The Suspension Bridge decoratively spans the drive next to the tennis courts. Neglected and in feeble condition, it was removed in 1929 and replaced soon after with a subterranean tunnel.

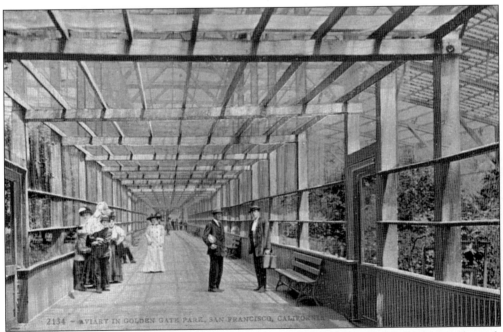

To better observe birds shown in the aviary, a 16-foot-wide tunnel led visitors through the center of the gigantic enclosure. An aviary was constructed here in 1890 and with its popularity a second, much larger one in 1892.

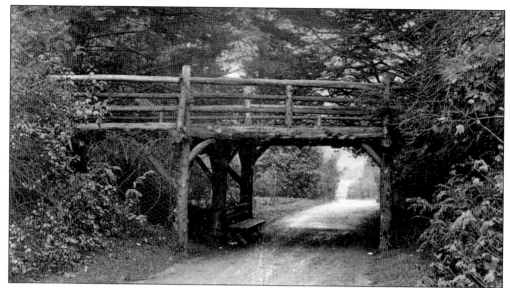

This rustic bridge, one of several originally placed in the park, was located somewhere in the eastern end. Made of unpeeled bark, the style espoused the ideals of communing with nature.

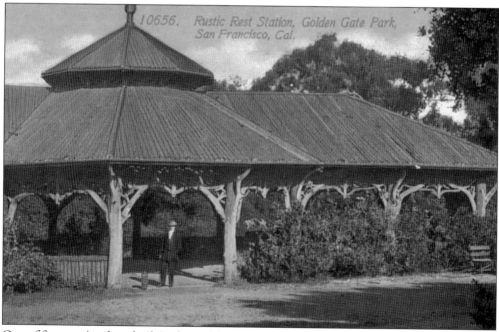

One of four rustic arbors built in the park's eastern end. They were crafted of natural wood logs and branches by Anton Gerster, who built similar structures for New York's Central Park.

The sky-reaching Native Sons Monument, whose bronze portions were sculpted by Douglas Tilden, sat on granite work designed by architect Willis Polk. The piece was initially installed in 1897 at the intersection of Mason and Turk Streets, then relocated in 1948 to the park's Redwood Memorial Grove. It was moved to its present spot on San Francisco's Market Street in 1977.

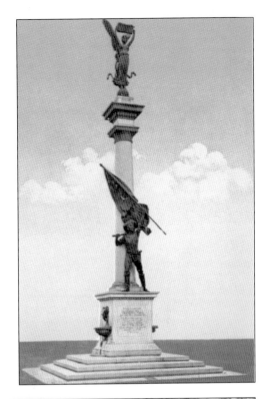

The Australian Tree Fern Dell once sported a fountain styled in the grotto manner dispensing refreshing water. The spot was also known as Bicycler's Rest, where there was a cluster of benches so cyclists could take repose. A huge cross-section of a redwood tree log stood upright, exposing its annular growth rings.

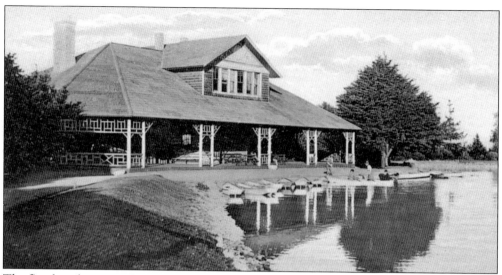

The first boat house on Stow Lake was built in 1893 to evoke the natural rustic style favored at the time. Architect A. Page Brown designed the structure that was demolished in 1937 when a replacement structure was built on the same site.

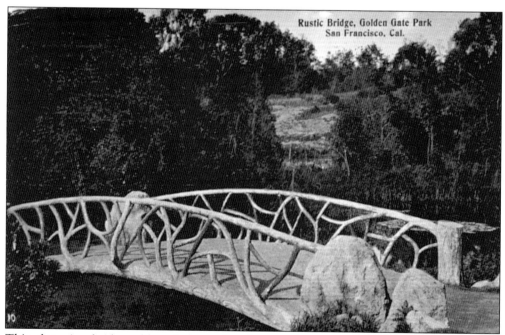

This charming bridge, although espousing the wooden rustic style, was in fact made of sculpted concrete to imitate wooden branches. It spanned one of the trio of the Chain of Lakes in the western end.

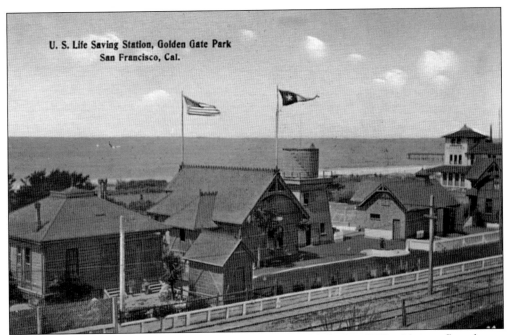

The picturesque U.S. Life-Saving Service station was established in 1878 with a surfboat house designed by local architect J. Lake Parkinson near the intersection of Fulton Street and Ocean Beach Boulevard. A keeper's dwelling was built in 1884 to the south of the boathouse based on a design of John B. Pelton. The Park and the old Ocean Railroad tracks are in the foreground.

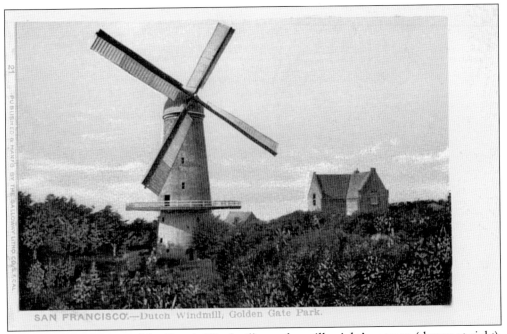

Located just northeast of the Dutch Windmill was the millwright's cottage (shown at right). Designed in a complementary Dutch style, the brick house burned down in 1958.

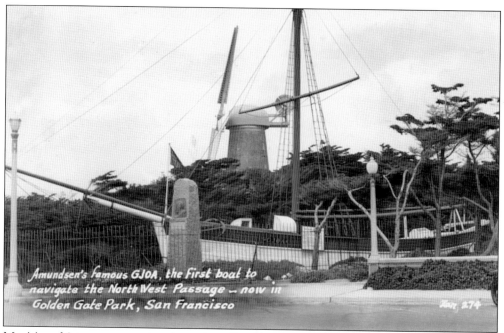

Maritime history was made when Capt. Roald Amundsen was the first to sail his sloop *Gjøa* through the Northwest Passage. With the three-year trip complete, he sailed into San Francisco in 1906. The ship was located directly in-line between the U.S. Life-Saving Service compound and Beach Chalet between 1909 and 1972.

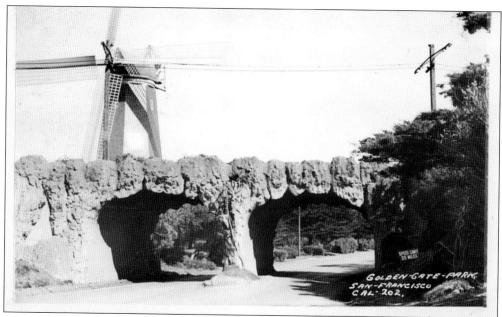

Located just west of the Murphy Windmill, huge boulders face the railway bridge's arched openings. The tracks were removed to contribute metal to World War II effort, and the bridge probably soon after. The abutments, however, remain today.

Seven

CREATURES OF MANY KINDS

Over time the park became home to many kinds of animals and birds from all over the world, both captive and free-range. Eventually there were so many creatures in the park it was decided that they be the inhabitants of a separate municipal zoo whose primary funding came from Herbert Fleishhacker. As an example of the park's inhabitants, publisher F.F. Byington noted Persian sheep and peafowl within Peacock Meadow in an 1894 publication, as well as some 150 bird species in the aviary. Waterfowl, including ducks, swans, and wild geese resided on Stow Lake, Chain of Lakes and Spreckels Lake. In the Children's Quarters, pony rides sat alongside barnyard goats and chickens. Deer, caribou, antelope, llama, moose, and, yes, even exotic animals like kangaroo and zebra were all once housed here. Sentimental feelings often come about with mention of the Bear Pit to those who remember its place—a living extension of the frozen dioramas inside the nearby Academy. Steinhart Aquarium rounded out the collection with an impressive collection of aquatic animals and fish.

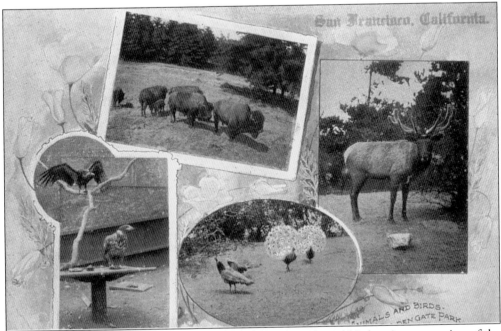

This multiview postcard shows some of the park's animals and birds prior to creation of the municipal zoo. California poppies, the official state flower, frame the vignettes.

Exotic peacocks roamed within a fenced area known as Peacock Meadow located just inside the park's eastern Panhandle entrance.

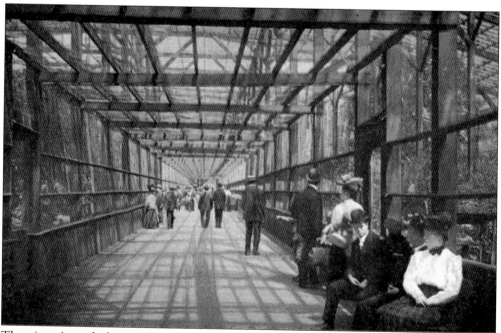

The gigantic oval-plan wood and mesh aviary had a tunnel running through its center so visitors could observe the many birds housed there. A 1914 guide published by the city's chamber of commerce cites "cockatoos, Alaskan ptarmigan, great California eagles and a riot of winged life" in captivity here.

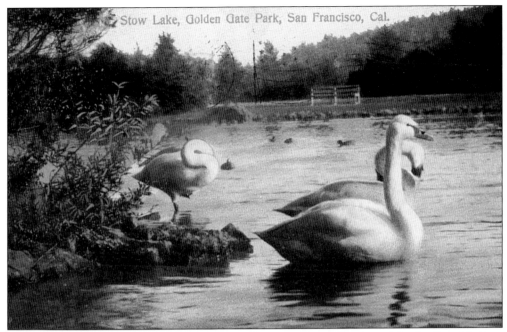

The waters of Stow Lake support a variety of waterfowl, and its three islands allow birds to nest safely away from land-borne predators.

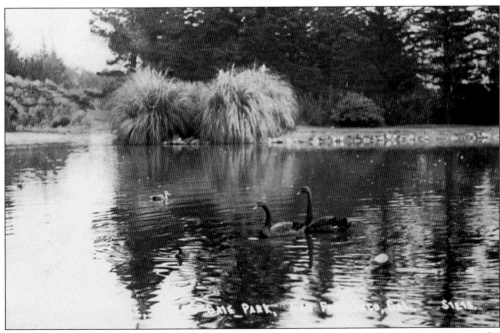

Black swans glide in Stow Lake's placid waters. The lake was created in 1893 just in time for the Midwinter Fair.

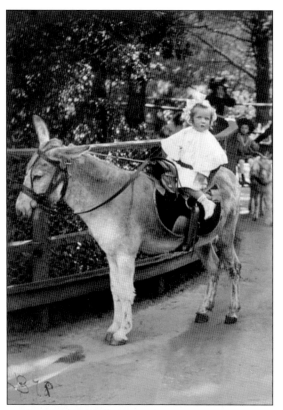

This postcard, postmarked 1909, shows a toddler riding a burro while another follows in a goat cart. The animals followed an enclosed looping path within the Children's Quarters.

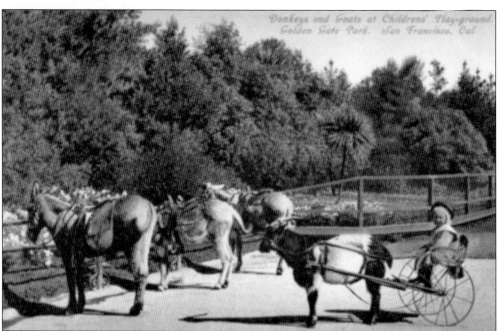

Visiting the Children's Quarters meant that a child could saddle up and ride a burro or sit in a sulky-like vehicle pulled by goat power.

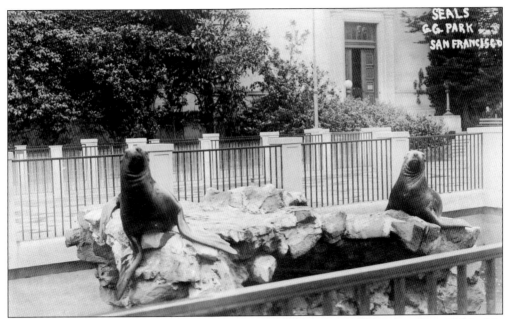

Shown here cavorting in the courtyard of Steinhart Aquarium, sea lions were first exhibited in the park at the Midwinter Fair's Santa Barbara Amphibium, a sideshow of aquatic animals.

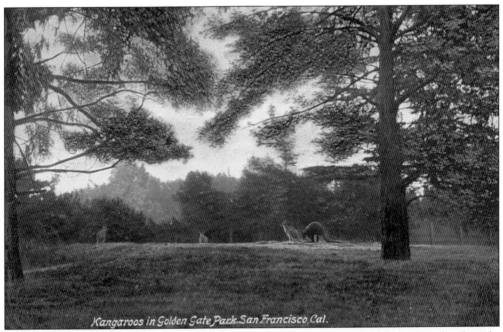

It's hard to cite when or where kangaroos were housed in the park. But maybe the thought was that if Australian eucalyptus trees were so successfully transplanted to California, then why not the "roo"?

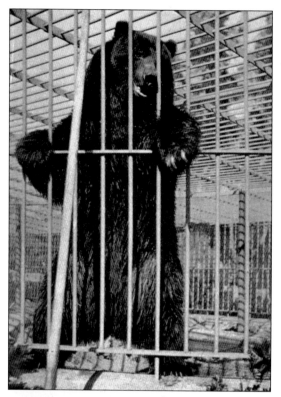

Monarch the bear was a favorite of children. His moniker came from the bear pit's benefactor William Randolph Hearst who proclaimed his *Examiner* newspaper "The Monarch of the Dailies." After Monarch died in 1911, the bear's remains were mounted and exhibited in the Memorial Museum.

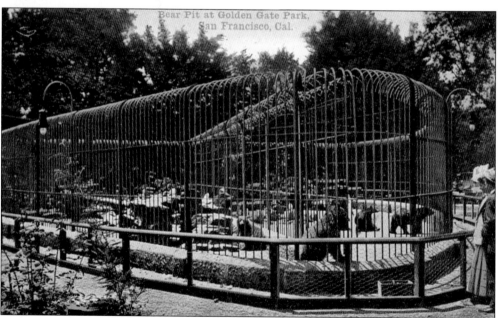

Architect Willis Polk designed the Bear Pit located just east of the California Academy of Sciences. Previously the Midwinter Fair's '49er Camp had a bear pit where Monarch was first shown in the park. Monarch, a California Grizzly and representative official state animal, was captured in 1889 in Southern California.

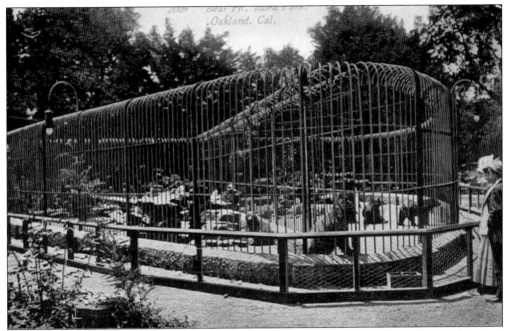

Although mislabeled by the manufacturer as "Idora Park," this postcard is otherwise identical to the one on the opposite page.

The bear pit remained in the park for some years after the city's municipal zoo was established and most other animals had been transplanted.

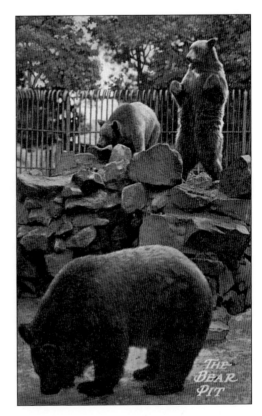

85

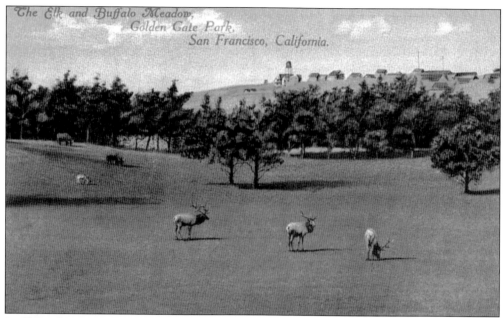

Buffalo (known today as the scientifically correct term bison) initially shared their paddock with elk and other hooved animals. This paddock was the park's second one, and was created in 1899. It was originally called Zeile Meadows and remains today, although it is now commonly known as the Buffalo Paddock.

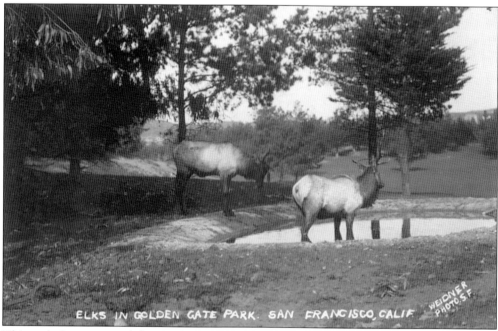

This real photo postcard shows what may have been known as Elk Glen, which is where Elk Glen Lake is located today.

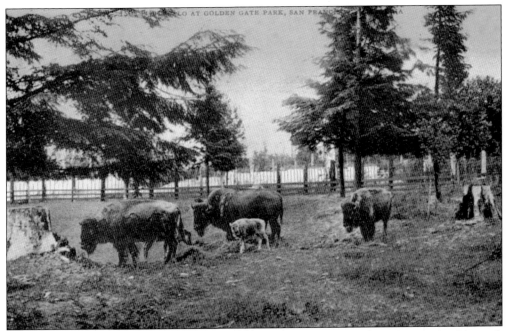

Buffalo shedding their hide is a messy affair for humans to behold. As we see in this card, shreds of skin drape off their bodies during the process.

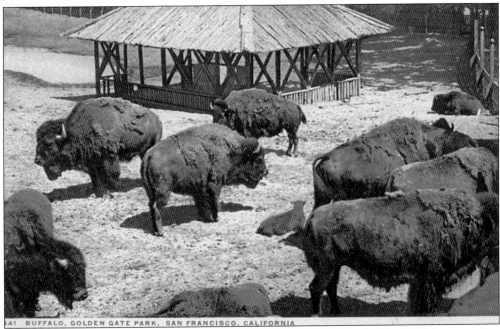

Rustic-style enclosures once provided a scenic vista and also provided the buffalo protection from the elements.

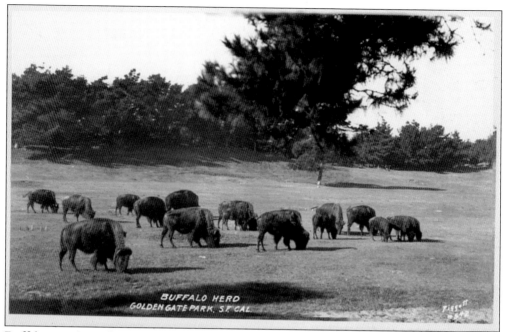

Buffalo were brought to the park in 1891, where they resided initially in a paddock just east of the Academy of Sciences. The animals apparently liked their quarters—breeding was so successful that some were sold or traded to other parks.

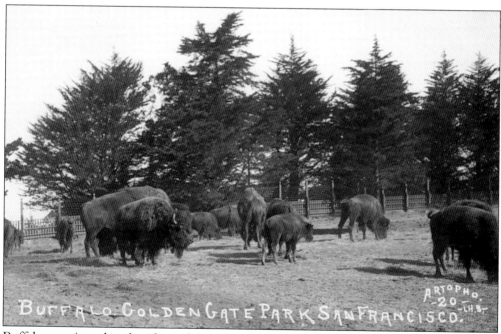

Buffalo were introduced to the park because early animal conservationists realized that there were dwindling numbers of the beasts in North America's plains. Efforts sprang up across the country to bolster the diminishing populations.

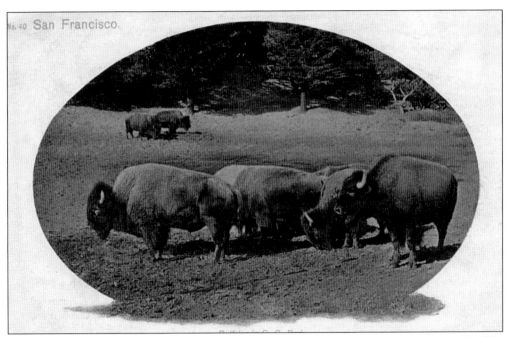

This charming oval-framed view of buffalo belies their strength. The escape of rogue buffalo always made the popular news since it was a major undertaking by park personnel to corral them back to their quarters.

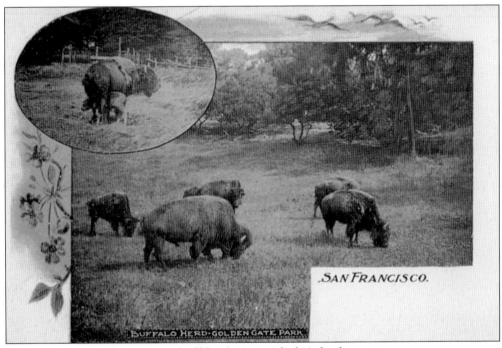

Another artistic postcard shows buffalo grazing with their husky young.

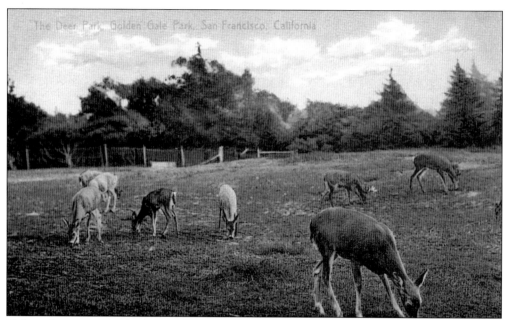

Dainty deer graze in the Deer Glen. This area appears to be where the park's maintenance and nursery yards stand today.

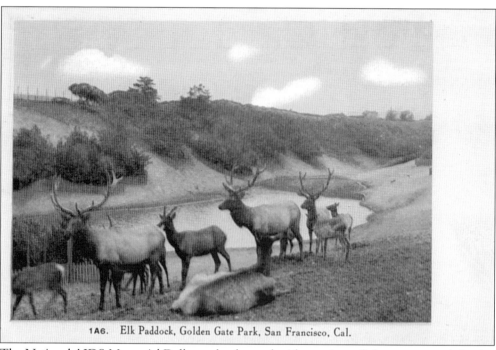

1A6. Elk Paddock, Golden Gate Park, San Francisco, Cal.

The National AIDS Memorial Dell now landscaped with a variety of plants, trees and shrubs, is the third incarnation of the original Deer Glen. The basin was improved by funds from the de Laveaga estate.

Eight
FANCY STRUCTURES

Some of the park's buildings have attained historic landmark status due to their unique design or important role and it's not surprising that these are among the most recognized symbols of the park. The structures included in this chapter range from late Victorian, Edwardian to classically inspired. The Victorian style was rooted in an eclectic mix of past architectural design concepts and the park became home to the style's innumerable expressions. Picturesque and rustic style buildings (Stow Lake boathouse and several bridges) had a homespun charm that appealed to everyone while the robust Romanesque form, like the Sharon and Lodge buildings, were constructed of locally quarried stone evoking an aura of permanence. And to decorate the park's landscape further were the exotic styles like Japonesque (tea garden), Dutch (the windmills and their keeper's houses), and neo-Egyptian (Memorial Museum) which were intriguing imports from another part of the world—places most people did not have access to see in those days. The old standby of classical Roman and Greek (Steinhart Aquarium, carousel enclosure, and bandstand) rounded out the collection. An anomaly was the delicate white painted wood framing of the Conservatory of Flowers that serves to house precious plants from climates much warmer than the Bay Area's. The concept of a wide span entirely of glass was inspired by London's Crystal Palace for the Great Exhibition of 1851, the first commercial use of the glasshouse idea.

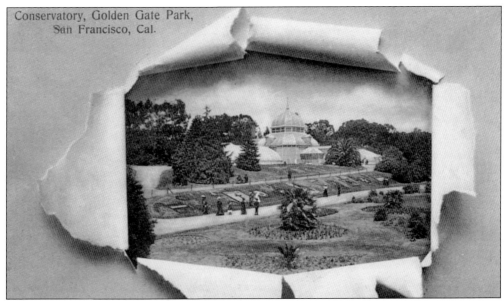

This postcard shows the ingenuity that publishers used to differentiate their cards from others, since the Conservatory of Flowers was such a popular subject.

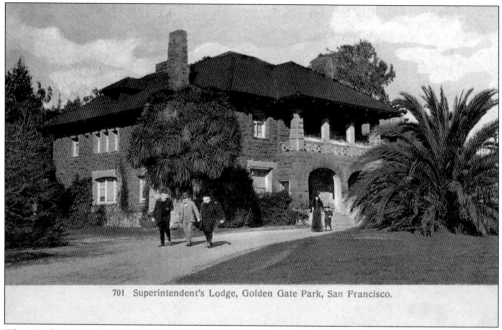

701. Superintendent's Lodge, Golden Gate Park, San Francisco.

The Lodge initially housed both the superintendent's family and the Park Department. After McLaren's death in 1943 the whole building was taken over by the newly combined Recreation and Park Department—and officially named McLaren Lodge.

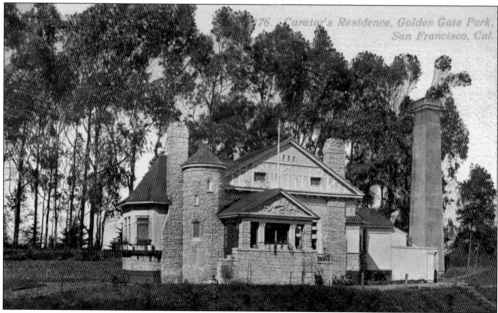

576. Curator's Residence, Golden Gate Park, San Francisco, Cal.

A remnant of the Midwinter Fair, this building was moved to a site just behind the original Egyptian-styled Memorial Museum in 1895. The Curator's Residence was initially constructed by J.A. McDonald of Oakland as a meeting place for Canadian fair attendees. After its move, the interior was completely remodeled for use by the museum's first curator Charles P. Wilcomb.

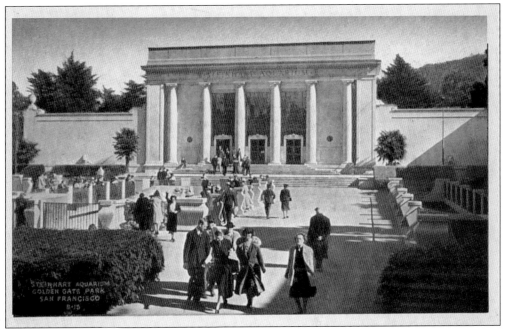

Talk of an aquarium in the park started in 1901 but the deed was not accomplished until years later in 1923, when the classically inspired second portion of the California Academy of Sciences complex was constructed.

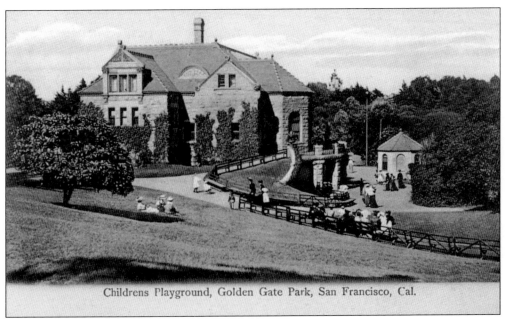

Childrens Playground, Golden Gate Park, San Francisco, Cal.

This card shows the view looking eastward toward the Sharon Building and the Children's Playground. Architects Percy and Hamilton designed the Romanesque-styled Sharon Building, which was funded by banker William Sharon.

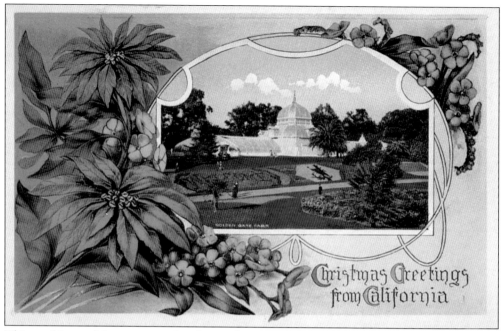

This card is an elaborate example of a combination holiday greeting card and illustration of the Conservatory of Flowers. These kinds of postcards conveyed how temperate Northern California was during the year's grayer time.

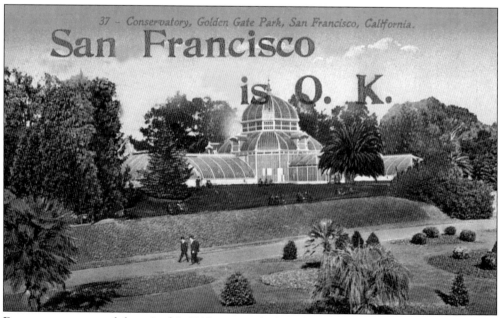

Boosters were at work here in this 1911-postmarked card to proclaim that San Francisco was a great place. The timing of this postcard coincides with the initial PPIE planning.

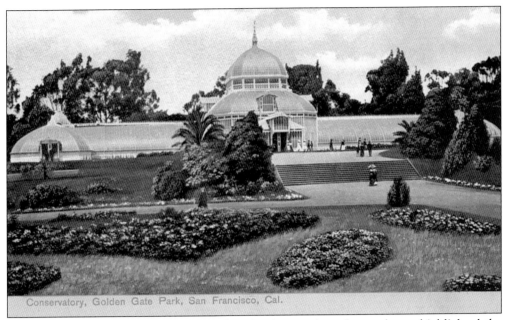

Conservatory Valley has seen many landscaping incarnations, but each one highlighted the decorative use of flowers and shrubs.

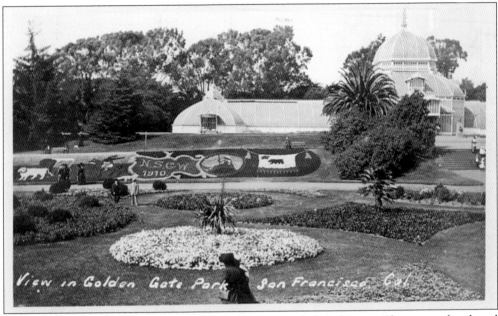

This 1910 real photo celebrates California pioneers and their history. Shown on the sloped embankment, from left to right, are Native Americans and wagons on the plains, Native Sons of the Golden West, Eureka (the California emblem), and the bear flag.

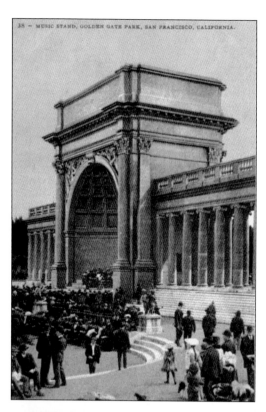

Spreckels Temple of Music was dedicated in 1900 with an appreciative audience of some 75,000 onlookers. Benefactor Claus "Sugar King" Spreckels donated the funds for its construction. Outdoor concerts started in the park with the first bandstand that was built in 1881.

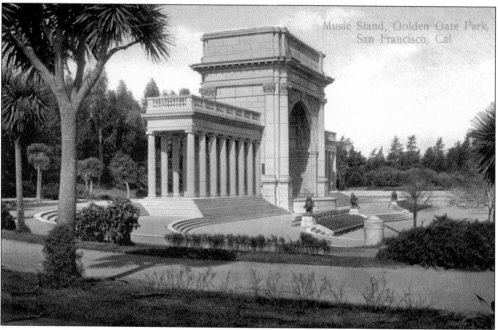

A quartet of giant bronzes depicting cupids once stood in front of the bandstand. Sculpted by Francois Lespongola, the pieces originally stood near the front entrance of the Memorial Museum. Later, they graced the pool of the Oakes Garden outside the de Young Museum.

PROGRAM
GOLDEN GATE PARK BAND
Ralph Murray, Director

"Independence Day"—Saturday, July 4, 1942
**Commencing at 2 P.M.
at the Golden Gate Park Band Stand**

This concert is presented for the entertainment of the people of San Francisco and their guests by direction of the Park Commissioners.

"There's *Music* in all things—if men had ears to hear."—Byron.

National Anthem, "The Star-Spangled Banner"

1. American Fantasia Bendix
2. Modern Rhapsody "Cypress Silhouettes" . Bennett
3. Waltz "Wedding of the Winds" Hall
4. Suite "Americana" Thurban
 (a) The Tiger's Tale
 (b) Serenade "When Malindy Sings"
 (c) The Watermelon Fete
5. Medley of Popular Standard Songs . . Briegel
6. Selection from "Faust" Gounod
7. American Sketch "Down South" . . Myddleton
8. Melodies from "The Fortune Teller" . Herbert
9. March "Hands Across the Sea" . . . Sousa

Nos. 3, 5, 6, 7 and 8 are played by request.

GOD BLESS AMERICA
The audience is invited to join in singing the chorus.

God bless America,
 Land that I love,
Stand beside her and guide her
 Through the night with a light from above;
From the mountains, to the prairies,
 To the oceans white with foam,
God bless America
 My home sweet home.

REQUESTS given to program boys or any member of the band, will gladly be played if possible, or included in a program on a later date.

SILENCE is urgently requested while the Band is playing, and parents are asked not to allow the children to play in front of band stand.

AUTOMOBILE OWNERS are requested not to sound horns or start motors while the Band is playing.

This playbill shows a Golden Gate Park Band program from Independence Day, July 4, 1942.

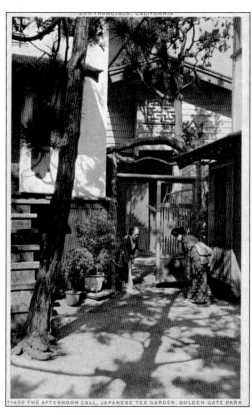

A visit of two kimono-clad women is captured in this postcard scene set among the traditional architecture of Japan.

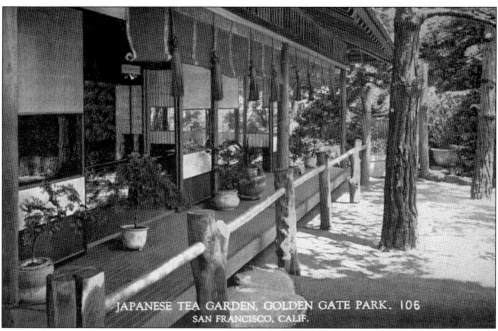

Post and beam construction (using traditional Japanese construction methods) was utilized in buildings within the Japanese Tea Garden.

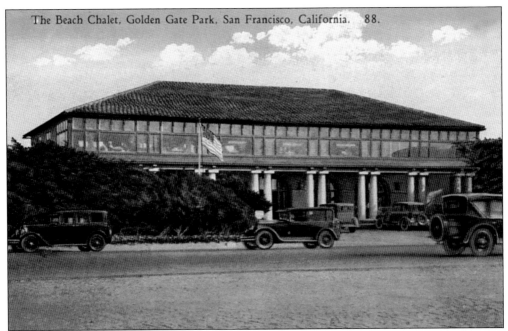

Facing the Pacific Ocean, the Beach Chalet opened in 1925. Architect Willis Polk designed the building, which functioned as a combination of changing rooms, lounge, and a public restaurant.

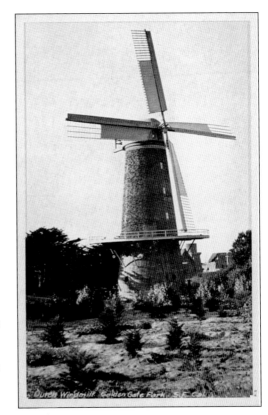

Who would have thought that, of anywhere within the park boundaries, Ocean Beach would have a fresh water source? The round, conical shaped Dutch Windmill was inaugurated in 1903 to provide the park's lifeblood to the park's western end.

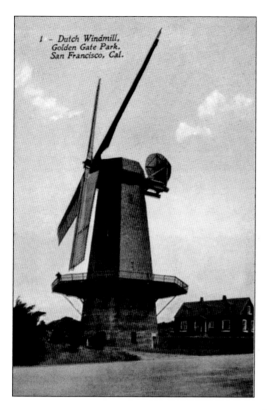

1 – Dutch Windmill, Golden Gate Park, San Francisco, Cal.

With the success of the Dutch Windmill, the octagonal plan Murphy Windmill followed suit, with its dedication in 1908. A keeper's cottage was built the following year based on a design by architect James W. Reid.

Another shot of the Murphy Windmill shows its earlier years, as it stood among sand dunes with sparse vegetation. Banker Samuel G. Murphy donated most of the funds to construct this gigantic pumping machine.

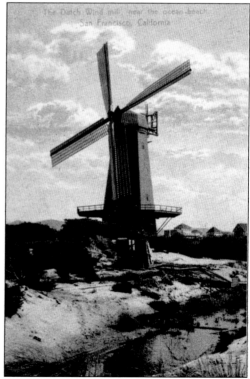

Nine

SYLVAN VISTAS

The poignant first line in Richard G. Turner's introduction to *The Trees of Golden Gate Park and San Francisco* states, "Trees are the cornerstone of Golden Gate Park." Few trees other than native coast live oak and willow originally grew on the park's landscape. These lived in concert with a sprinkling of coarse native shrubs that persevered on the barren rippling sand dunes created by the ever-present gusty Pacific Ocean landward winds. Park designer William Hammond Hall considered the undulating sandscape when laying out roadways and paths, as he realized that winds would take a toll on any attempt to landscape. Consequently, he (and later his protege John McLaren), worked with the physical layout at hand rather than attempt to manipulate it. However, even four years into the reclamation process, the state of groundcover was beginning "to clothe itself in a rough and dingy verdure" according to a March 1901 article in *Overland Monthly*. Design sensitivity played a role here too, since an undulating visual path would create picturesque vistas as well. Today this urban forest is composed of diverse tree specimens beyond those that initially stabilized the landscape's shifting sands.

Here we see one of the park's many rustic strolling lakeside paths, possibly along Stow or North Lake, shaded by eucalyptus trees. Although not native to the United States, the eucalyptus imported from Australia grew well in the park and helped to keep the subsoil (actually sand) in place.

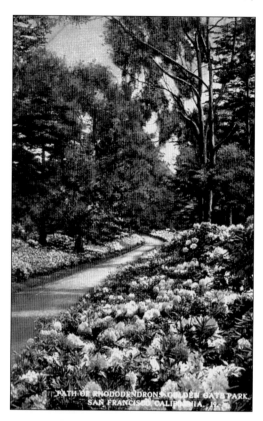

This card shows a path through the original rhododendron dell that was located where Kezar Stadium is now sited. The rhododendron was John McLaren's favorite flower.

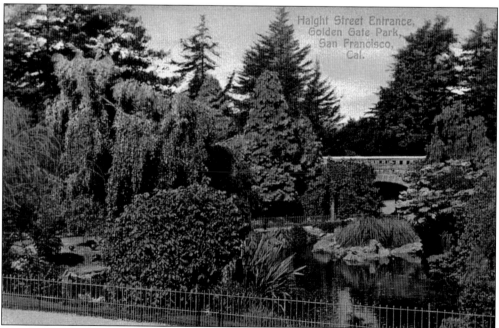

The path surrounding Alvord Lake leads from the Haight Street gate and through the stalactite-filled Alvord Bridge tunnel toward the many delights of the Children's Quarters.

Another of the park's walkways, possibly located in the eastern end of the park, is shown in this card.

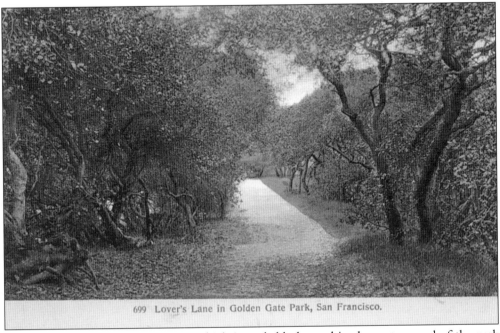

This postcard shows Lover's Lane, which is probably located in the eastern end of the park where stands of native coast live oak have thrived for generations.

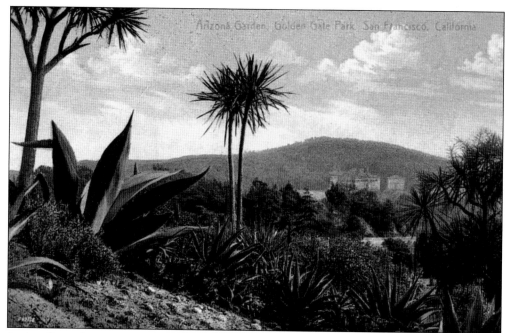

A view from the upper portion of the Arizona Garden toward the Affiliated Colleges located on the slope of Mt. Sutro is seen here. Succulents still reign on this warm south-facing slope, located just east of the Conservatory. The garden's origin dates from the Midwinter Fair.

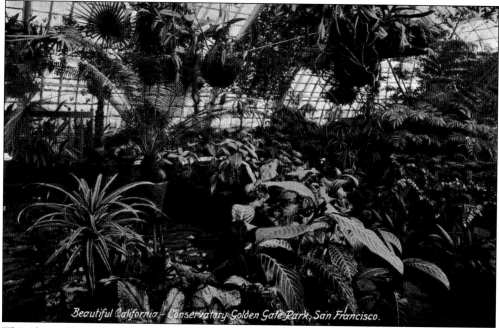

This shot, although taken of the interior of the Conservatory of Flowers, seems to depict a jungle more than any exterior place in the park. Exotic specimens of all kinds thrive in the conservatory's warm and moist artificial climate.

Some postcards show unrecognizable spots such as this one.

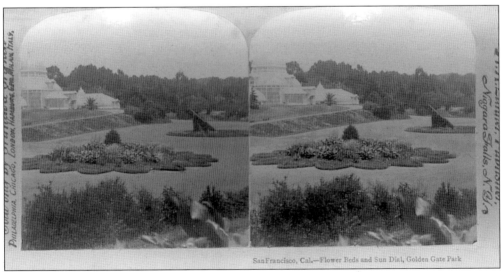

Conservatory Valley is shown in this stereo view, showing fancy planting beds as well as a gigantic floral sundial (on the right) installed in 1891. The valley's profile was regraded in 1939 to the one seen today.

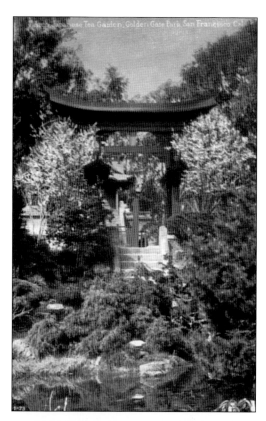

In this card, stairs on a steep embankment climb to a gate in the Japanese Tea Garden. Exotic trees and shrubs, many specially pruned, abounded in the garden.

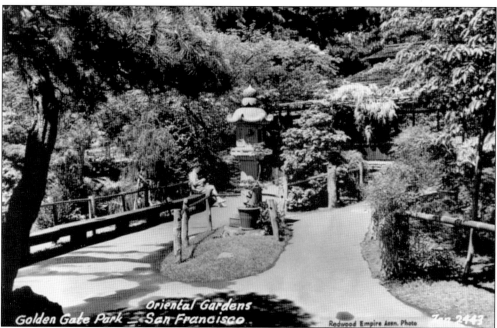

A variety of trees, including pine, create the magical landscape shown here along pathways of the Japanese Tea Garden.

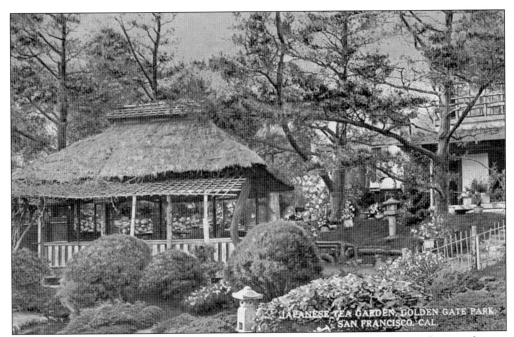

Decorative carved stone lanterns punctuate the landscape around the garden's teahouse. Makoto Hagiwara is credited with creating the exotic landscape; his family carried on the tradition after his death.

Ironically, California was not so beautiful for the Hagiwara family. In 1942 the family was forced to an internment camp as a consequence of World War II. The garden's name was neutralized with a change to Oriental Tea Garden.

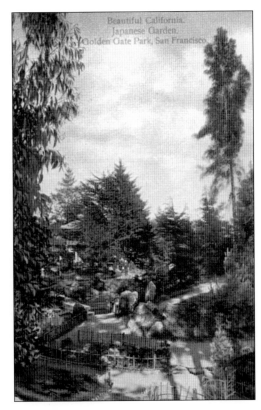

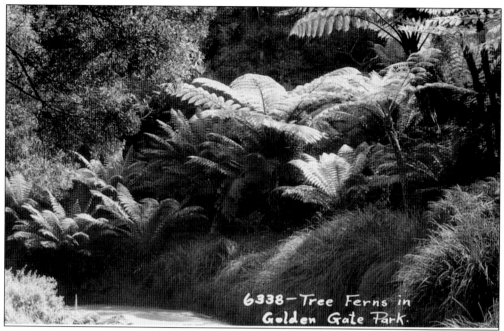

Today the exotic Australian Tree Fern Dell is a forest of mostly Tasmanian tree ferns. Pathways lead to the Lily Pond whose edges rise abruptly to expose bedded red-brown chert rock laid down eons ago.

This pathway leading between the Conservatory of Flowers and the tennis courts was known as the Rockery with its large stones interspersed with various botanical specimens.

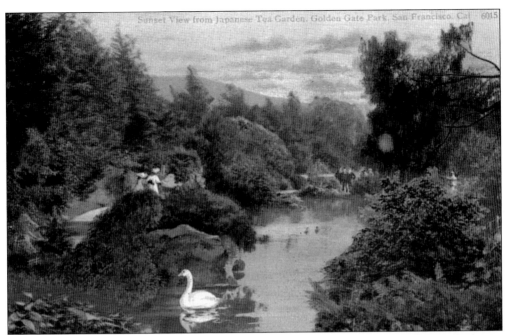

A colorful sunset was often shown in postcards whose color was artificially overlaid onto black-and-white images. A sunset as exotic as this one is quite rare in San Francisco.

This card shows what is most likely a lakeside view of North Lake, one of the Chain of Lakes which consists of North, Middle, and South Lakes.

In this card, a groundcover of yellow daisy-like flowers brightens a drive through the park. Roadways for carriages were initially paved in park-quarried crushed chert rock, and later with asphalt as automobiles began rolling through the park's roadways.

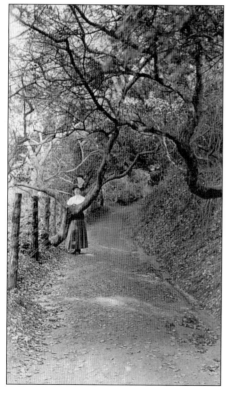

This 1914 real photo postcard shows a woman who signed the card "Agnes C." She stands on one of many of the park's pathways, probably located in the eastern end.

Ten

BEFORE AND AFTER

Change is part of life's grand scheme, and people are naturally curious to see what happens after a transformation takes place. Owing to the great number of park-specific postcards created in its 133-year history (I have heard one figure estimating some 5,000), there are postcards that portray what is the same place but at different times. Two great events had an effect on the park—the earthquake of 1906 and Midwinter Fair. Luckily I can exclude the word "fire" from the former event since none is known to have occurred within the park as a consequence of the calamity; unfortunately conflagrations did not spare the downtown areas. Buildings and monuments were toppled in the well-documented disaster. Shortly thereafter, the park became a refuge for those suddenly without homes. Those who now called the park home created a change in the landscape when camps were set up in open fields; that change was ultimately undone when John McLaren pushed the stragglers out and his crews expended endless hours returning the park to its original state.

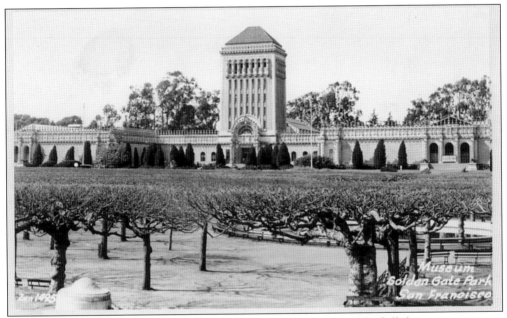

A poignant step in the de Young building's history was the removal of all the cast concrete exterior ornamentation in 1949. Many people might have assumed that this was just another modernization effort that was popular in that era. In fact, the sculpted decorations created a hazard when they started falling off the structure in 1931.

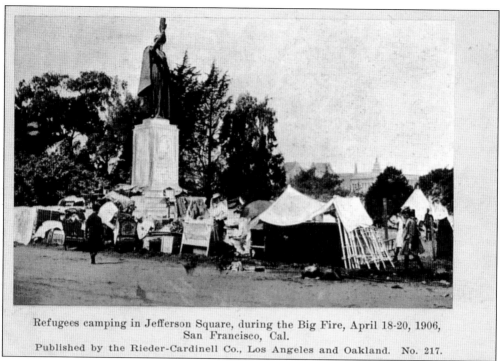

Refugees camping in Jefferson Square, during the Big Fire, April 18-20, 1906, San Francisco, Cal. Published by the Rieder-Cardinell Co., Los Angeles and Oakland. No. 217.

Refugees flocked to the park as the 1906 quake's aftershocks continued. This postcard's caption incorrectly notes this as Jefferson Square rather than The Panhandle.

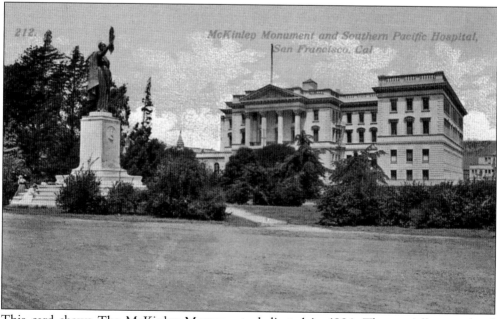

This card shows The McKinley Monument, dedicated in 1904. The partially completed Southern Pacific Hospital on Fell Street is in the background.

This hill, one of the few natural outcroppings in the park, was also quarried for its red-brown chert rock that was crushed to pave the park's early roadbeds.

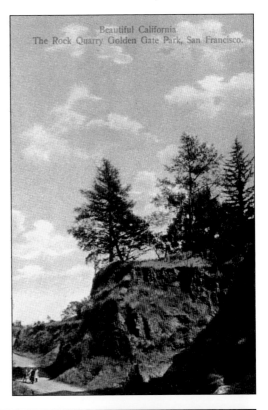

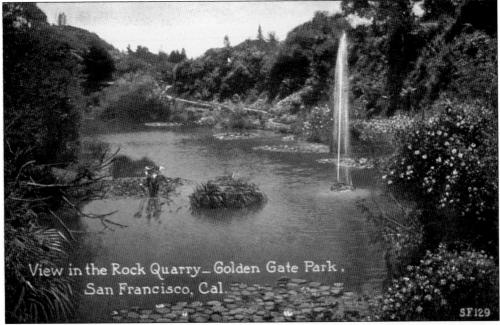

It was very nearly an act of alchemy to turn a former quarry into a secluded water pond filled with lily pads and waterfowl. This transformation, in 1902, turned the quarry into the Lily Pond, also known as Cook's Lake.

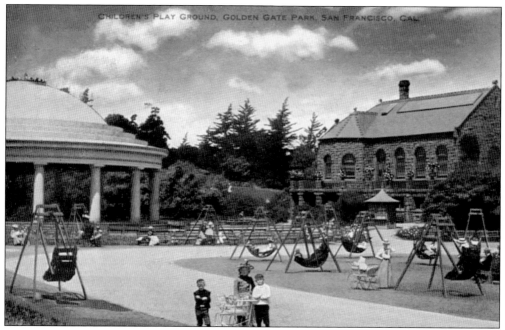

This card depicts the Sharon Building (at right), which was completed in 1888 as part of the Children's Quarters. Skylights lit the large main room with its exposed structural roof trusses.

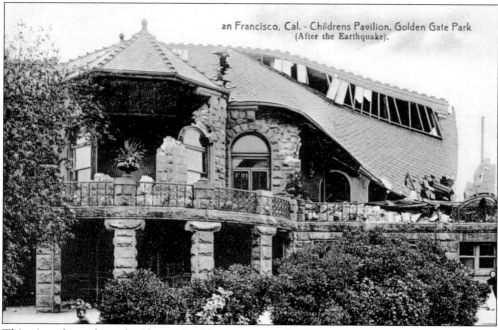

This view shows how the Sharon Building was completely restored to its former appearance, despite structural damage that occurred. Two fires occurred later, but like a phoenix rising, the building was repaired to like-new appearance.

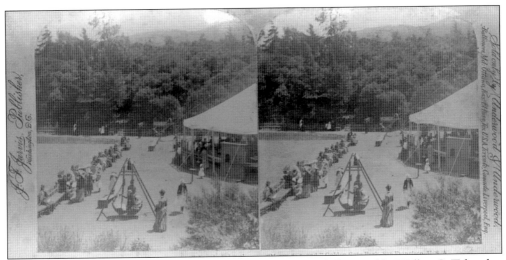
This image from a stereoview card shows the original carousel, designed by Walker C. Tyler, that commenced operation in 1888. It had a simple carnival-like tent to protect it from the elements.

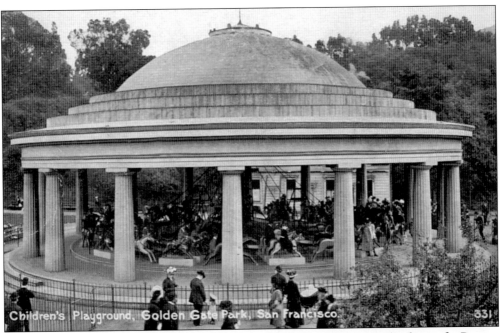
Architect A. Page Brown designed a permanent carousel enclosure in the form of a Roman temple with Doric columns, seen in all its original glory in this depiction. It was constructed in 1892 entirely of wood and remains a favorite attraction today.

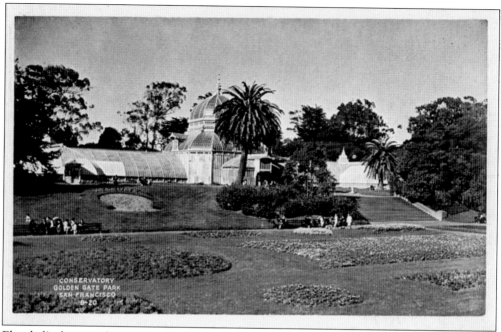

Floral displays, such as the one shown here in front of the conservatory, go back to the late 1900s. The circular shape (at left on the hillside) with a splayed bottom lies fallow between displays.

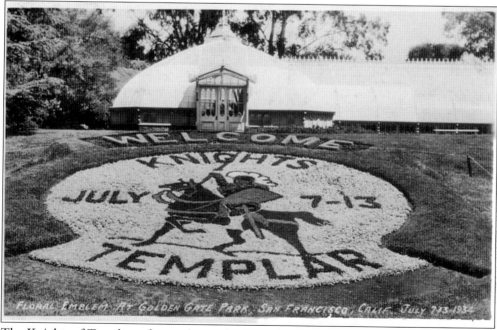

The Knights of Templar, a fraternal organization who met in San Francisco, is celebrated in this 1934 postcard.

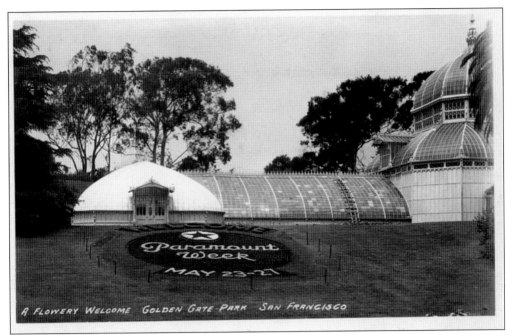

Paramount Pictures must have liked San Francisco during the company's early days. Starting in 1916 and continuing through at least 1931, the titanic international film studio held its annual convention of executives in San Francisco.

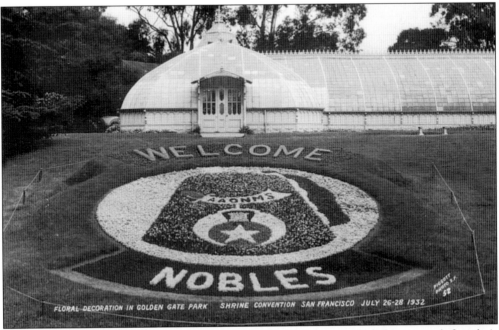

This 1932 floral plaque shows the Shriners' iconic red-tasseled fez created for their convention held in 1932. Fraternal organizations played a big part in the social lives of men until about the mid-20th century.

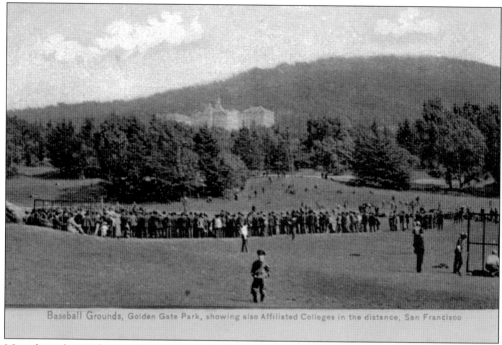

Baseball Grounds, Golden Gate Park, showing also Affiliated Colleges in the distance, San Francisco

Noted on the Midwinter Fair map as "Athletic Grounds," the broad open plot of land shown here became known as Big Rec, the park's primary field for baseball diamonds.

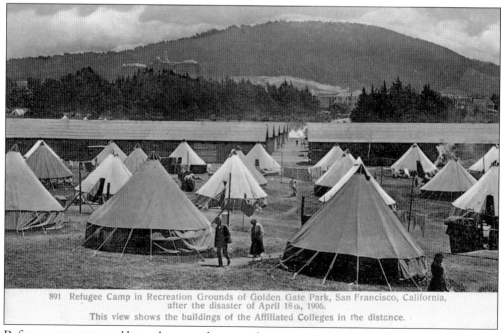

891 Refugee Camp in Recreation Grounds of Golden Gate Park, San Francisco, California, after the disaster of April 18th, 1906.
This view shows the buildings of the Affiliated Colleges in the distance.

Refugee camp tents and barracks cover the grounds once committed to baseball in this surprising picture. Some people overstayed their welcome, and park authorities had to force them to leave.

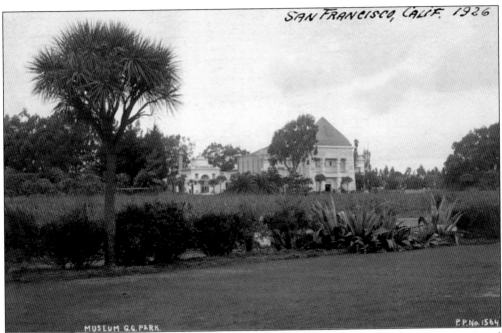

The Memorial Museum and Bavarian Pavilion stand alone in this real photo postcard dated 1926. The view looks north across the tops of leafless trees blanketing the Music Concourse's recessed basin.

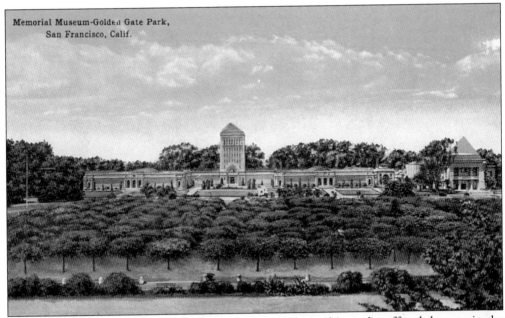

The Egyptian-styled Memorial Museum (seen at right in this card) suffered damage in the 1906 earthquake but was repaired. Its fate was sealed in 1928, after having been declared unsafe years earlier, and it was demolished. A new addition to the rear of the 1921 museum building grouping, designed by architect Frederick H. Meyer, was about to be built to allow expansion of the growing collections.

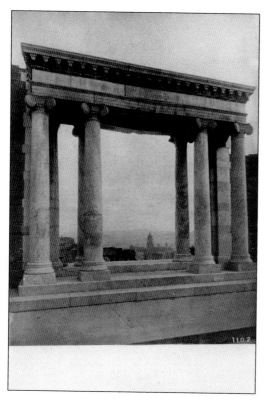

The front portal of the Towne residence atop Nob Hill was all that remained of the home after fire swept through the neighborhood, a consequence of the 1906 earthquake. The iconic vista shown here, originally recorded by photographer Arnold Genthe, became part of San Francisco lore.

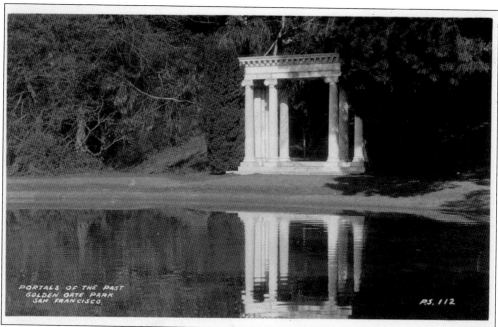

Portals of the Past got its name when poet Charles Kellogg Field found a quote, the words of which espoused the forward-looking nature of San Franciscans who survived the 1906 earthquake and fire.

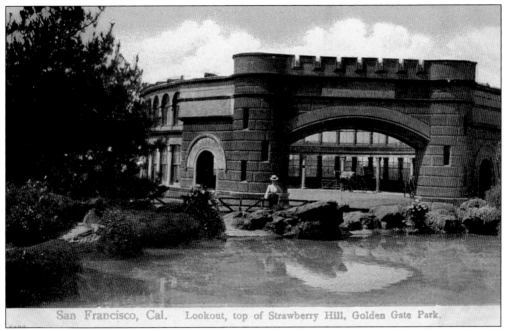

Thomas U. Sweeny's one-story observatory on Strawberry Hill, seen here, was doubled in height because his gift to the city became very popular. It had no roof, but the structure's openings had glass to protect visitors from wind.

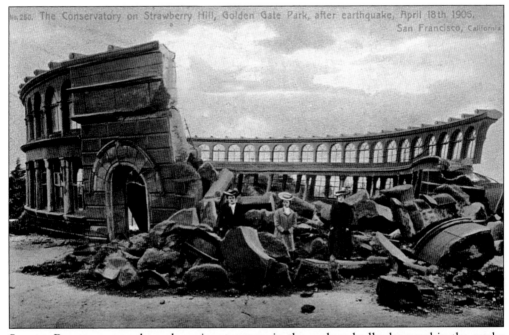

Sweeny Panorama was the only major structure in the park so badly damaged in the quake that it was never rebuilt. Made of cast concrete with some metal reinforcing, the building's lacy perimeter tilted and cracked, and the entry portal completely collapsed.

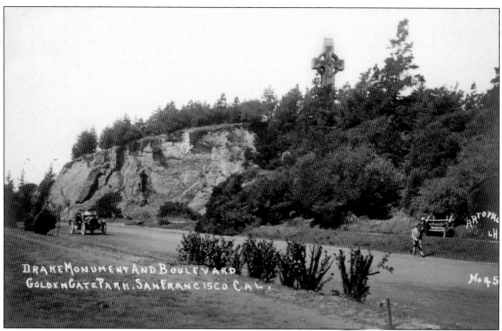

Drake's Prayer Book Cross commands the top of this hill. But below it stood a unsightly dump which occupied an area once quarried for its rock (like Lily Pond) to pave the park's roadways.

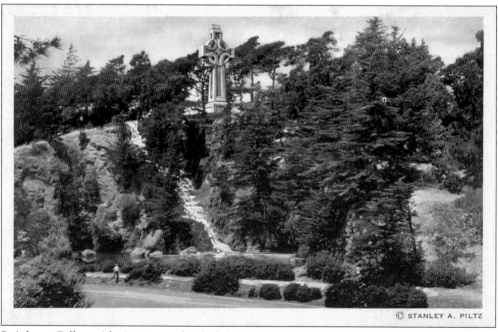

Rainbow Falls, with its namesake lighting system, was dedicated in 1930 during the beginning of the Great Depression. The lighting was achieved by constructing arches of colored lights above the cascade. Remnants of the rusted arches can still be seen in the cascade's watercourse

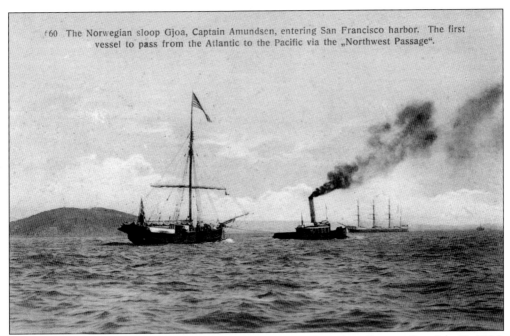

The Norwegian sloop *Gjøa* is shown here entering San Francisco Bay on October 19, 1906, fresh from her three-year journey through the Northwest Passage. Formerly a herring sloop, c. 1872, the ship was altered to perform the momentous task.

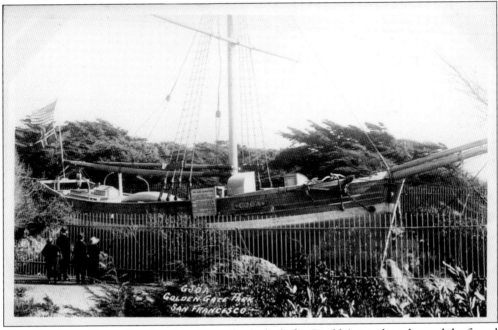

The *Gjøa* sits on Ocean Beach, where it was drydocked after Roald Amundsen donated the famed ship to San Francisco. Sadly it turned to a wreck over time, although restoration efforts were attempted, and in 1972 Norway took the boat back to Oslo, Norway, where it sits restored.

Selected Reading

Babal, Marianne. *Golden Gate Park Master Plan-background report, historical element.* San Francisco: The (San Francisco Recreation and Park) Department, 1993.

Blair, Hosea. *Monuments and Memories of San Francisco: Golden Gate Park,* 1955.

Board of Park Commissioners. *The Development of Golden Gate Park and the Management and Thinning of its Forest Tree Plantations.* San Francisco: Bacon and Company, 1886.

Byington, F.F. *Official Guide to Golden Gate Park of San Francisco.* San Francisco: Board of Park Commissioners, 1894.

Chandler, Arthur and Marvin Nathan. *The Fantastic Fair: The Story of the California International Exposition.* St. Paul, Minnesota: Pogo Press, 1993.

Clary, Raymond H. *The Making of Golden Gate Park: The Early Years, 1865–1906.* Second edition. San Francisco: Don't Call It Frisco Press, 1984.

––––. *The Making of Golden Gate Park—The Growing Years: 1906–1950.* San Francisco: Don't Call It Frisco Press, 1987.

––––. *The Story of the Windmills.* Windmills restoration edition, San Francisco: The John McLaren Society, 1971.

Day, J. and J.L. *An Illustrated and Descriptive Souvenir and Guide to Golden Gate Park.* San Francisco: J. and J.L. Day, 1914.

The M.H. de Young Memorial Museum. San Francisco: San Francisco Park Commission, 1921.

Ellison, Joan, ed. *A Survey of Art Work in the City and County of San Francisco.* San Francisco: Art Commission, City and County of San Francisco, 1975.

Giffen, Guy and Helen. *The Story of Golden Gate Park.* San Francisco, 1949.

Girvan Aikman, Tom. *Boss Gardner: The Life and Times of John McLaren.* San Francisco: Don't Call It Frisco Press, 1988.

Goethe and Schiller Monument. San Francisco: Leidecker and Company, 1902.

Golden Gate Park Master Plan Draft. San Francisco Recreation and Park Department, 1994.

Hall, William Hammond. "Influence of Parks and Pleasure Grounds." Biennial Report of the Engineer of the Golden Gate Park, for term ending Nov. 30, 1873. *Overland Monthly* II, no. 6 (December 1873).

Ishihara, Tanso and Gloria Wickham. *The Japanese Tea Garden in Golden Gate Park (1893–1942)*. Saratoga, California, 1979.

Lippmann, C.R. *A Trip Through Internationally Famous Golden Gate Park, San Francisco, CA*. San Francisco: The Printing Corporation/F.W. Woolworth, 1937.

Mailliard, Joseph. *The Birds of Golden Gate Park*. San Francisco: Academy (of Sciences), 1930.

Mallick, George L. *The Artificial Lakes of Golden Gate Park*. San Francisco: 1973.

McClintock, Elizabeth. *The Japanese Tea Garden, Golden Gate Park, San Francisco*. San Francisco: John McLaren Society, 1977.

McClintock, Elizabeth and Richard G. Turner, eds. *The Trees of Golden Gate Park and San Francisco*. Berkeley: Heyday Books, 2001.

One Hundred Years in Golden Gate Park. The Fine Arts Museums of San Francisco, 1995.

Pollock, Christopher. *San Francisco's Golden Gate Park: A Thousand and Seventeen Acres of Stories*. Portland, Oregon: WestWinds Press, 2001.

Pruett, Herbert E. *The Golden Gate Park*. Oakland: Pruett-MacGregor, 1968.

San Francisco Civic Art Collection: A Guided Tour of the Publicly Owned Art of the City and County of San Francisco. San Francisco: San Francisco Art Commission, 1989.

San Francisco Recreation and Park Department. *The Plan for Golden Gate Park, Objectives and Policies* San Francisco: Recreation and Park Department, 1978.

Shanks, Ralph. *Guardians of the Golden Gate: Lighthouses and Lifeboat Stations of San Francisco Bay*. Petaluma, CA: Costaño Books, 1990.

Shanks, Ralph and Wick York. *The U.S. Life-Saving Service: Heroes, Rescues and Architecture of Early Coast Guard*. Petaluma, CA: Costaño Books, 1996.

The Monarch Souvenir of Sunset City and Sunset Scenes. H.S. Crocker, 1894.

The Official History of the California Midwinter International Exposition. H.S. Crocker, 1894.

In Remembrance of the Midwinter International Exposition, San Francisco, Cal. 1894.

Levinson, Alan E. and Michelle L. Adrich. *Theodore Henry Hittell's The California Academy of Sciences: A Narrative History 1853–1906*. San Francisco: California Academy of Sciences, 1997.

Robbins, Fred Strong. *Facts and Fancies of the Tour thru Godden Gate Park, Sightseeing, Automobile or Walking*. San Francisco: F.S. from Prayer Book Cross to the ocean Robbins, c. 1916.

Schlereth, Thomas J. *Victorian America-Transformations in Everyday Life 1876–1915*. New York: Harper Collins, 1991.

The Simson African Hall of the California Academy of Sciences. San Francisco: Crocker-Union, 1937.

Wilson, Katherine. *Golden Gate Park: The Park of a Thousand Vistas*. Caldwell, ID: Caxton Printers, 1947.

Witemann, A. *The California Midwinter International Exposition*. New York: The Albertype Company, 1894.

Index

Alvord Bridge, 6, 102
Alvord Lakelet, 4, 6, 61, 102
Apple Cider Press statue, 25, 63
Arizona Garden, 72, 104
Australian Tree Fern Dell, 75, 108
Aviary, 73, 80

Beach Chalet, 99
Bear Pit, 84–85
Big Rec, 2, 56, 116
bison paddock (buffalo), 86–88, 89
Burns Memorial, 14

California Academy of Sciences, 13, 42–50, 63, 93
California Midwinter International Exposition (Midwinter Fair), 16, 19, 20–21, 25, 92, 104
carousel, 2, 54, 115
Chain of Lakes, 70, 109
Children's Playground, 54–55, 82, 102, 114–115
Conservatory of Flowers, 26, 53, 56, 72, 91, 94–95, 104–105, 117–118
Curator's Residence, 92

de Laveaga Dell, 90
M.H. de Young, 30
de Young Museum, 30–31, 33–41 111
Deer Glen, 90
Doré Vase, 24
Dutch Windmill, 77, 99, 100

earthquake (1906), 28, 62, 67, 112, 116, 119–120
Elk Glen Lake, 86,

Favorite Point, 72
'Forty-Nine Camp, 25

Garfield Monument, 2, 13, 53, 105
Gjøa, 78, 123
Goethe and Schiller Monument, 16
Golden Stairs, 72
Grant Monument, 2, 15

Halleck Monument, 12
Huntington Falls, 66, 69

Japanese Tea Garden, 22-23, 64, 65, 98, 106–107, 109

Key Monument, 4, 11, 13, 35, 52

Lily Pond, 113
Lion Statue, 18
Lloyd Lake, 68
Log Cabin, 24

McKinley Monument, 12, 112
McLaren Lodge, 4, 92
McLaren Statue, 14
Mechanical Arts Building, 21
Memorial Museum, 2, 11, 18, 21, 29, 33–34, 92, 119
Monarch, 84
Morrison Planetarium, 50
Murphy Windmill, 59, 100
Music Concourse (Concert Valley), 57

Napoleon Room, 32
National AIDS Memorial Grove, 90
Native Sons Monument, 75

Panama-Pacific International Exposition (PPIE), 26–28, 30
Panhandle, 80
Park Stadium (Polo Field), 27–28, 59
Peacock Meadow, 80

Pool of Enchantment, 16, 62
Portals of the Past, 68, 120
Prayer Book Cross, 18, 122

Rainbow Falls, 122
Redwood Memorial Grove, 75
Rhododendron Dell, 102
Rockery, 108
Roman Bridge, 58
Roman Gladiator statue, 20
Royal Bavarian Pavilion, 31, 32, 119
Rustic Arbors, 74
rustic bridges, 74, 76, 78
rustic stone railway overpass, 59, 78

San Francisco Model Yacht Club, 51, 69
second bandstand, 71
Serra Monument, 15
Sharon Building, 93, 114
Simson African Hall, 48–49
Spreckels Lake, 51, 69
Spreckels Temple of Music, 2, 57, 96
Steinhart Aquarium, 42-45, 63, 83, 93
Stow Lake, 6, 58, 67, 81
Stow Lake Boathouse, 58, 76
Strawberry Hill, 6, 62, 69, 121
sundial, 17
suspension bridge, 73
Sweeny Observatory, 69, 121

Tennis Courts, 52–53, 73, 108
Towne residence, 120

U.S. Life-Saving Service station, 60, 70, 77

Verdi Monument, 17

Zeile Meadows, 86